Jill Bays

Drawing Workbook

A COMPLETE COURSE IN TEN LESSONS

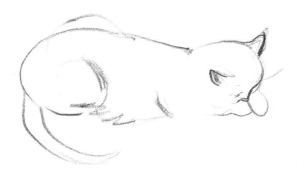

David & Charles

ACKNOWLEDGEMENTS

Many thanks to my family and friends who have been so helpful, and to my models: Caroline, Georgina, Victoria and others. Thanks also to Eileen Hiner for deciphering my handwriting and to Freya Dangerfield and Susanne Haines for their support and help. And finally, thanks to Daler Rowney for supplying materials used in the photographs.

A DAVID & CHARLES BOOK

First published in the UK in 1998
First paperback edition 2001

A catalogue record for this book is available from the British Library.

ISBN 0 7153 0719 3 (hb)
ISBN 0 7153 1232 4 (pb)

Edited by Susanne Haines
Book design by Les Dominey Design Company, Exeter
and printed in Italy by New Interlitho SpA

for David & Charles
Brunel House Newton Abbot Devon

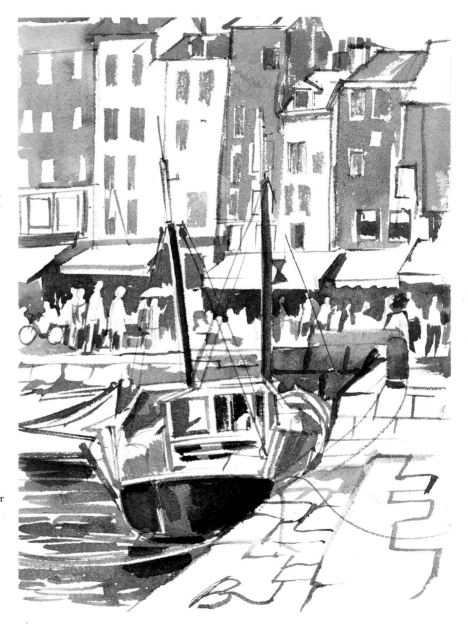

Contents

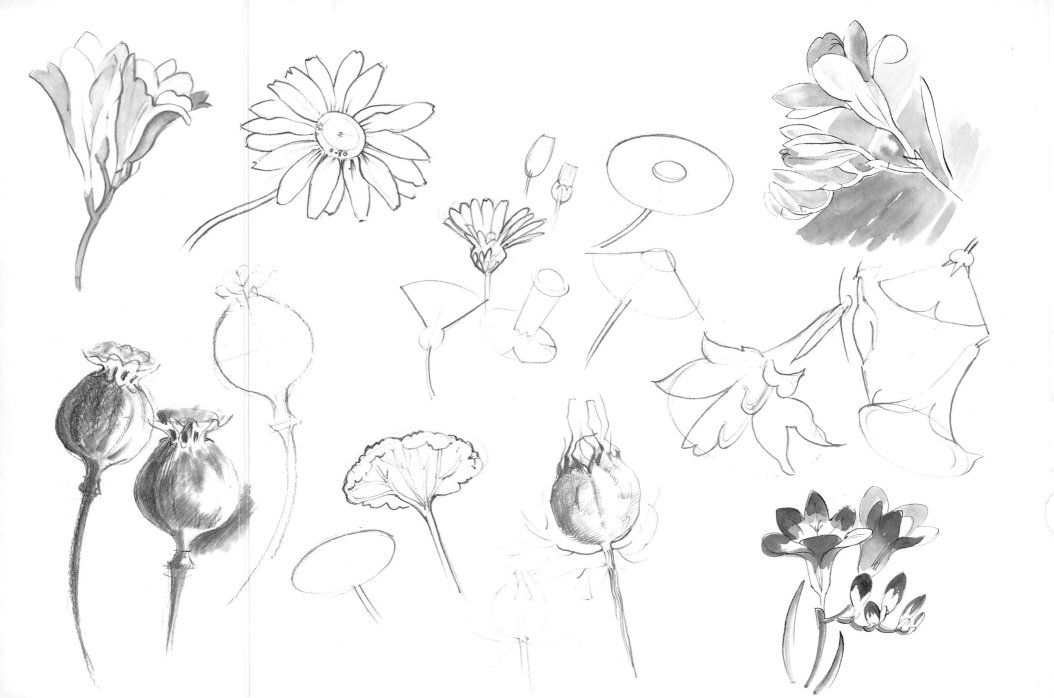

Introduction

Every child loves to draw, and most adults can express a simple idea in the form of a drawing, such as a diagram, for instance. However crudely done, a drawing always means something.

The majority of people write, and can learn to draw just as easily. The ability to draw can be learnt, and although some people do seem to be better at drawing than others, this is probably because they have taken trouble and have practised. You need only the very minimum of materials to start: just paper and pencil, which most people possess anyway.

Drawing can give you a whole new way of life – you can learn to look differently, to appreciate craftsmanship, and to develop your creativity. It will certainly enlarge your vision of the world, and will give you confidence to tackle other kinds of problems.

Drawing is a way of expressing yourself, of communicating your feelings, and enjoying life. When you draw a leaf that has become a fragile net of veins you are really marvelling at the wonder of nature, and finding a way of capturing that fragility.

Drawings can take any shape, size or form, and can be executed in a great number of ways. Look at the drawings scratched onto prehistoric cave walls, or drawings made by children in the sand on the beach, or your own doodlings while you are on the telephone.

As you look at illustrations in books and magazines, or when you go to exhibitions, you cannot fail to be impressed by the number of ways of drawing. Each artist develops his or her way of drawing and these drawings are often instantly recognisable and individual. How can you achieve this?

For me, the only way is by constantly drawing and practising – then eventually your own individuality and style will emerge. Certain styles of drawing are probably already familiar, and you will learn to employ different methods depending on the subject you are drawing, the materials you choose, and the effect you want to create.

USING THIS WORKBOOK

The aim of this book is to help you understand and practise ways of drawing using a variety of media, including pencils, charcoal, pens, brushes and wash, pastels and crayons. It encourages you to explore your materials and the marks you can make with them, before attempting to draw a recognisable object. It will give you an understanding of the use of tone to express form, of ways to render texture and pattern, of ways of using and mixing colour, of composition and perspective.

The lessons are arranged in a progressive way, so it is advisable to work through the book, as each lesson will prepare you for the next. Use the book as a starting point for exploring the enjoyment of drawing. To make the most of it, be prepared to find your own subjects and to experiment with your own ideas and materials.

SKETCHBOOKS

The last lesson in the book sums up the value of sketchbooks for your drawing. Having a sketchbook with you at all times and using it as often as you can is one of the most helpful things you can do. For instance, when you are on holiday, use it to record your memories – you will remember every detail – and you will have seen so much more than the camera can record.

Above all, draw as much as you can. In this way you will begin to find your own means of expression.

Materials and Equipment

The only essential materials you need to make a start with drawing are pencils and paper. However, you will soon find that you need a knife to sharpen your pencil, an eraser to remove mistakes, and a drawing board on which to fix your paper.

Start with what you already have, and add to your materials gradually as and when you need them. There are starter sets of certain materials, such as coloured pencils and pastels, which ensure that, as a beginner to drawing, you will not make too many expensive purchases.

On these pages I have listed the materials and equipment that will be used in this book. However, look in art shops for other materials that you may want to use, and look out for new products that are brought onto the market.

Pencils Graphite pencils are available in different grades of softness (H is hard, B is soft). Start with a 2B, 3B, 4B and 6B. Carbon pencils give a softer line.

Graphite sticks Made of solid graphite, without a pencil casing, so that the side as well as the tip can be used.

Watersoluble graphite pencils Line and tonal marks can be blended with water applied with a brush. They are particularly useful for sketching.

White chalk Use ordinary blackboard chalk, or white soft pastel.

Charcoal and charcoal pencils One of the oldest drawing materials, essentially charred wood (willow or vine), which is available in sticks of different thicknesses, usually in boxes. Charcoal is ideally suited to tonal drawing. For most of the exercises in this book use thin sticks, which can be used for line as well as tone. Scene painter's charcoal is thick and can be useful for very large-scale work. Compressed charcoal gives a much darker line that is not so easy to smudge. Charcoal should be sprayed with fixative to preserve the drawing. Charcoal pencils (available in different grades of softness) allow for less messy handling and can give a sharper line.

Conté crayons and pencils Natural pigment bound with gum arabic and sold as crayon sticks or pencils. Black, white and a range of subtle browns and reds; also a wide range of all colours. Available in different grades, from hard to soft.

Dip pens Pen holder with interchangeable flexible metal nibs; pointed for drawing, or with a chisel edge for broader marks.

Fibre-tip pens A growing variety of pens is available, both waterproof and non-waterproof, permanent and non-permanent, with points of different width, and in most colours. They are very convenient (and so are useful for sketching) as they carry their own supply of ink. Some have brush tips.

Reed pens and bamboo Buy these or make them yourself (see page 61).

Ink Waterproof Indian ink is the most useful for the pen and brush drawings in this book. It can be diluted with water to produce a range of greys. There are many different types of ink, both waterproof and non-waterproof, in a wide range of colours.

Drawing board A sheet of plywood, 533 x 380mm (21 x 15in) is a useful size for A3 paper. When working indoors you can use the back of a chair to rest your board against, or you can prop it up on a couple of books on a table.

Craft knife A knife with a fixed blade is preferable to one with retractable blades. Use a knife instead of a sharpener for sharpening pencils.

Putty rubber A soft eraser that can be used to lift charcoal and pastel from the paper. Small pieces can be pulled off and kneaded to any shape required and to reveal new usable areas.

Plastic eraser For cleaning up and rubbing out marks.

Torchon, or tortillon A paper stump used for blending charcoal and pastels.

Metal ruler Use for ruling, measuring, and as a guide for a knife when cutting paper.

Masking tape Use for attaching paper to a drawing board. Also as a material for masking out areas of drawing with washes.

Bulldog clips Alternative method for attaching paper to a board, or to keep paper clipped together.

Storage box Keep your materials stored in a container.

Clockwise from top left Graphite pencils, carbon pencil, graphite stick, watersoluble pencil, white chalk, charcoal, charcoal pencil, compressed charcoal, conté pencils, conté sticks, ink – waterproof Indian ink, reed pen, dip pen, torchon, fibre-tip pens, bulldog clips, craft knife, putty rubber, plastic eraser, drawing board, metal ruler, masking tape.

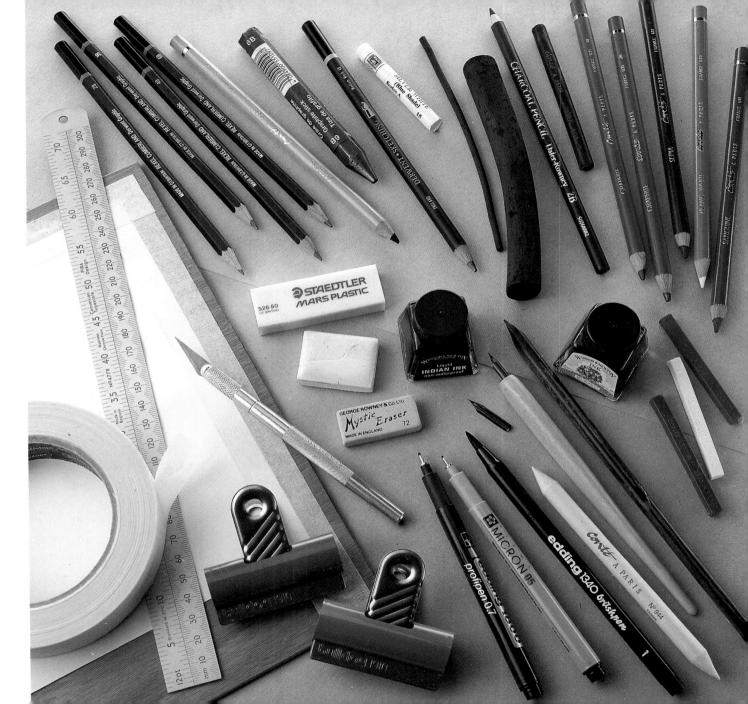

As you develop your drawing skills, you will find that you look to a wider range of materials. Most of the materials listed on this page are for working in colour.

Pastels The artist's soft pastel is a spontaneous medium which gives a broad chalky mark. Hard pastels (which include conté sticks) are better suited to linear work, and to laying down broad areas of colour. The range of colours and tints is large. If you are a beginner, it is sensible to buy a small boxed set to start with until you know which colours you are most likely to use.

Pastel pencils A pencil form of the hard pastel, which allows a finer line and less messy handling.

Oil pastels Available in bright and intense colours, they are used in a similar way to pastels but are rather greasy (and do not need to be fixed). They can be blended with white spirit or turpentine to produce an oil-paint effect.

Wax crayons Fairly similar to oil pastels, but not as bright, and more greasy. They can be used with water-based paint or ink to create a resist effect.

Coloured pencils or crayons A delicate and precise medium. You should invest in a good range of high-quality pencils; they give a much finer result than cheap sets.

Watersoluble coloured pencils Available in a wide range of colours and in two grades of softness. The colour dissolves on contact with water, softening and diffusing the marks to give watercolour effects. They are very useful as a sketching medium.

Watersoluble coloured crayons These can be used in the same way as the pencils, but they give a broader mark.

Watercolour Available in tubes, pans (small blocks of colour) and half-pans. Start with three primary colours (red, yellow and blue): cadmium red, cadmium yellow and ultramarine. When you are more experienced, add burnt sienna and Prussian blue. Alternatively, buy a small boxed set of watercolour.

Gouache Opaque water-based paint. A tube of white gouache is useful for adding highlights to drawings.

Palette Use a china palette or a white dinner plate or saucer. A plastic palette is a useful lightweight alternative as part of your sketching equipment.

Watercolour brush Start with just one: a medium-size (No. 7) synthetic round brush. Sable hair brushes are good, but expensive.

Fixative Used for fixing charcoal and pastel drawings, it is sold in aerosol cans, or as a liquid that is sprayed onto the drawing with a diffuser. Make sure that you fix your drawings in a well-ventilated room, or better still outdoors.

Easel An easel is useful but not essential. A sketching easel (either wood or metal) is helpful if you are working outdoors.

Other materials See page 53 for a list of other materials and equipment that will be useful for the experimental techniques in Lesson Four.

Clockwise from top left Oil pastels, fixative, coloured conté crayons, watercolour pans, or tubes, gouache paint, palette, watercolour brush, watersoluble coloured pencils, coloured pencils, watersoluble coloured crayons, pastel pencils, soft pastels, wax crayons.

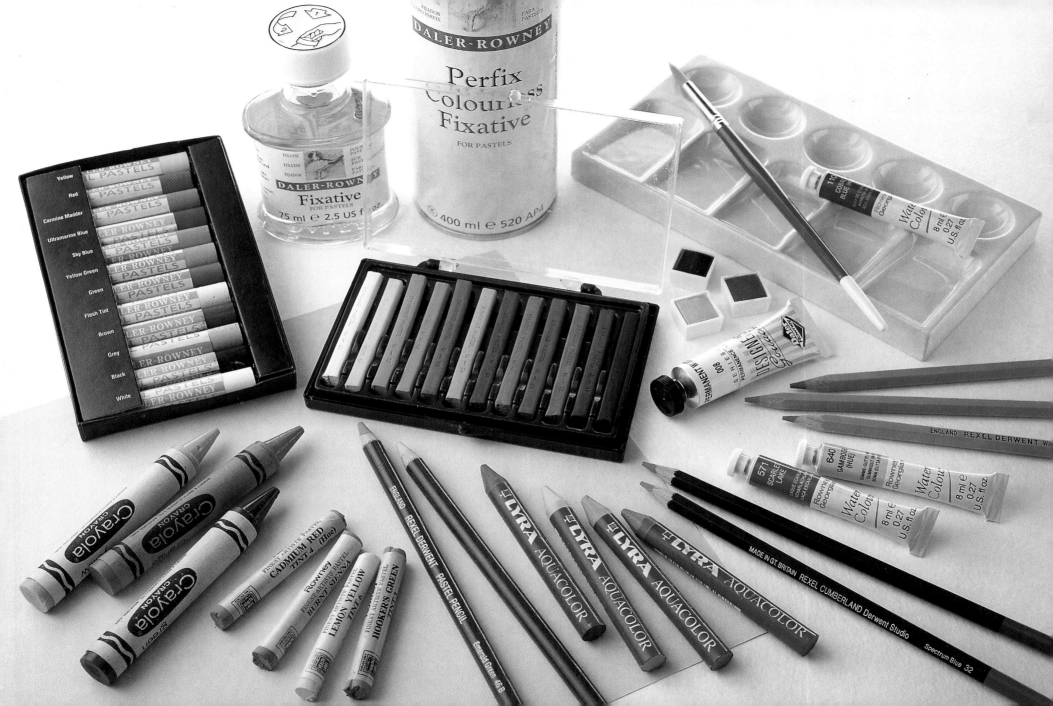

PAPER

For most of the early exercises in this book, the most useful purchase you can make is an A3 (420 x 297mm/$16\frac{1}{2}$ x $11\frac{3}{4}$in) size pad of cartridge paper of medium weight and with a smooth surface. Try to use paper of an adequate size – many beginners equate small with easy and this is not the case.

There is a very wide range of paper available, and different papers are suited to different materials. For instance, pen and ink and coloured crayons work well on paper that has a smooth surface, which will take a lot of detail. Pastels, however, need a paper with a 'tooth' (a textured surface) that will hold the pigment particles. Be prepared to experiment with various papers; some paper suppliers will let you have samples to try out.

It is useful to know something about weight, sizes and surfaces of papers.

WEIGHT

The weight of paper determines its thickness. It is expressed in grams per square metre (g/m^2, or gsm), or pounds per ream of 500 sheets (lb).

Weights range from 135g/m^2 (65lb) for a medium-weight drawing paper to a heavyweight 640g/m^2 (300lb).

I recommend a weight of 135g/m^2 for work with pencils, charcoal and other 'dry' media. For drawings that involve 'wet' media (ink or watercolour washes) you will need a heavier paper (at least 185g/m^2), otherwise the paper will tend to cockle as it expands and contracts with the action of the water. To prevent cockling, you can stretch your paper before you draw (see page 59).

SIZE

Paper is generally sold according to one of two different systems of measurement. Most commonly, for drawing papers, the international A sizes are used, each size being half the size of the previous one, for example: A1 840 x 594mm (33 x $23\frac{1}{2}$in); A2 594 x 420mm ($23\frac{1}{2}$ x $16\frac{1}{2}$in), and so on, to A6. A3 is a useful size for drawings; A4 is the standard writing-paper size.

The traditional, imperial sizes are also used for some of the better-quality papers: imperial 30 x 22in (762 x 559mm) and half imperial 15 x 22in (381 x 559mm).

SURFACE

The surface of a sheet of paper is determined by the way the paper-making process is finished.

Hot-pressed (HP) paper has a smooth surface, suitable for detailed work. Not or cold-pressed is neither rough nor smooth, but has a slight 'tooth', which is useful for watercolour and pastel. Rough paper has quite a rugged surface.

PAPER TYPES

Cartridge paper The most useful paper for most types of drawing, its whiteness ranges from bright white to cream (and there is also a range of coloured cartridge papers). It comes in various weights, sizes and qualities; buy the best you can afford, but be prepared to use it extravagantly. It can be bought in pads, but works out cheaper if bought by the sheet, cut to size and kept in a folder. Sheets of paper glued into a pad are best removed before using.

Use a hot-pressed paper for line, fine-detailed work and pen and ink, and a thicker not-pressed paper (185g/m^2) for drawings that include washes.

Pastel paper There are several types of pastel paper, available in a range of subtle tints, in two weights (90 and 160g/m^2). Ingres paper is one of the best-known pastel papers. Sugar paper is an economical alternative (the cream, brown and grey are useful colours), but it is a poor-quality paper and its life is not very long.

Watercolour paper Watercolour paper is available in weights ranging from 150g/m^2 to 638g/m^2. To avoid the need to stretch

the paper to avoid cockling, use a paper of $300g/m^2$ or more. It is available in the three different surfaces (see above).

Other papers Some stores stock handmade and exotic papers, such as Japanese papers, which are interesting to explore.

Sketchbooks Sketchbooks vary considerably in size, format, binding and paper type. Try different ones to find out which suits you best. I find that it is useful to have one medium-size A4 sketchbook, and an A6, pocket-size sketchbook, which I can carry with me at all times.

STORAGE

If possible, store paper flat, ideally in a folder or a drawer. If you do have to roll it up, do so loosely as it can be difficult to uncurl it.

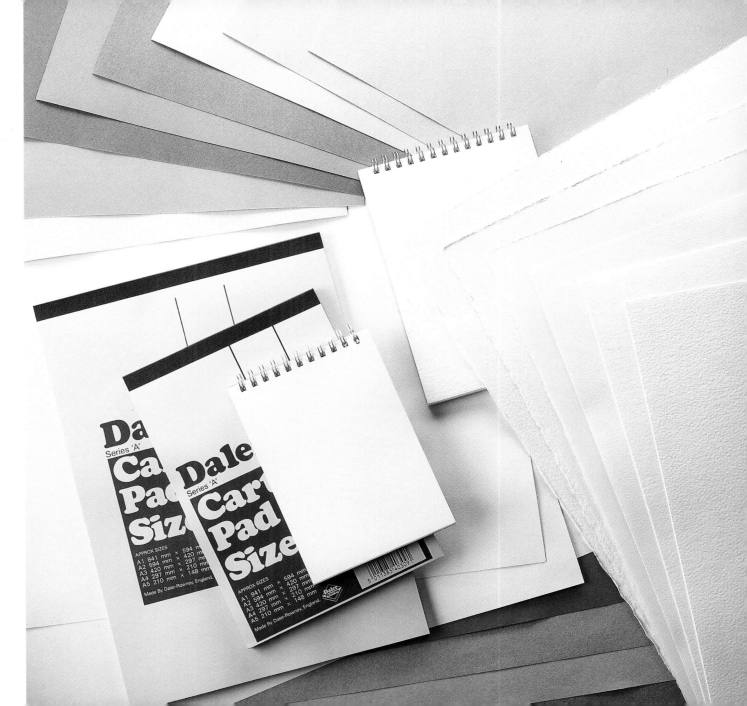

Clockwise from top left Pastel paper, watercolour paper, sugar paper, cartridge paper, a selection of sketchbooks.

Making Marks

We are all used to writing with a pen or pencil, but most of us are not familiar with the wide range of expressive marks that these tools are capable of making. There is also a wide range of materials to be explored.

PENCILS

Pencils are a good tool to start with, and most people possess at least one (usually an HB, or medium-hard grade for writing). For general-purpose drawing a 2B is useful, and softer pencils can be used for darker lines and shading.

Set yourself up with a drawing board and a sheet of A3 cartridge paper, and sharpen

Aims

- To explore the variety of marks you can make with pencils
- To discover the effect of the paper surface on the marks
- To try out a range of media, such as pens, charcoal, crayons and pastels
- To combine media, and to see how they work together

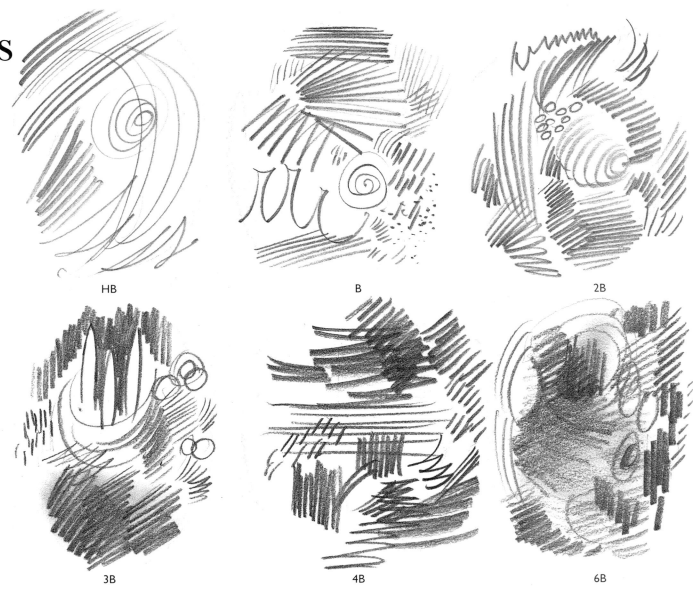

HB

B

2B

3B

4B

6B

your pencil to a long sharp point. Start by imitating the marks I have made on this page, working at approximately the same size. Then try making your own marks; doodles, dots, marks of different thicknesses, curved, straight, looped and dashed lines.

Try holding the pencil near the point, and then further away, and vary the pressure. Notice the difference this makes to the marks you produce.

Pencil marks can be smudged or softened with an eraser or with a finger. The softer the grade of pencil, the easier it is to smudge, and the darker the mark.

PAPER SURFACE

The texture of the paper has a considerable effect on the marks that you make. You will find that you can achieve more detail on a smooth surface, especially with the harder pencils, but on rougher papers it is easier to smudge and blend your marks. Explore this by making a range of pencil marks on at least three different types of paper.

Marks made by (*from left to right*) HB, B, 2B, 3B, 4B and 6B grade pencils on three different surfaces.

Smooth hot-pressed cartridge paper; a good all-round surface, suited to most grades of pencil.

White pastel paper has a surface with a 'tooth' that offers some resistance to the pencil marks.

Rough watercolour paper gives a more textured pencil mark.

EXPLORING OTHER MEDIA

Now begin to broaden your knowledge of other drawing media. They can be loosely categorised as those that make broad lines or fine lines, and those that are used 'dry' or 'wet' (requiring the use of water).

CONTÉ AND CHARCOAL

Media that make broad marks, such as conté and charcoal, tend to lead to drawing on a larger scale. They are useful for tonal effects (see Lesson Three), and can give a strong yet soft line that can be blended and smudged. Charcoal and conté are also available in pencil form, which allows you to make finer lines.

Crayons and charcoal are often held in a different way from pencils – within the palm of your hand. Try different hand positions until you feel comfortable using the medium.

PENS

By applying pressure on the flexible point of a dip pen you can vary the thickness of the line (see pages 56-7). Fibre-tip pens tend to produce a fairly regular line until the ink begins to run out; a reed pen can give a lively and unpredictable line.

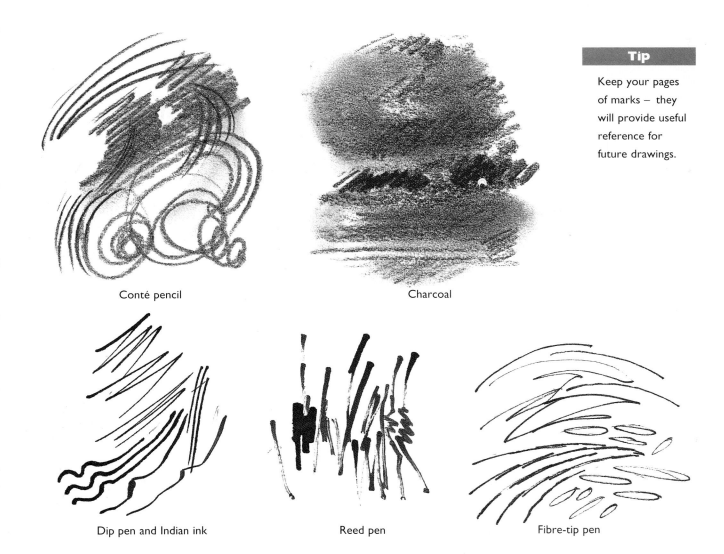

Conté pencil

Charcoal

Dip pen and Indian ink

Reed pen

Fibre-tip pen

Tip

Keep your pages of marks – they will provide useful reference for future drawings.

For a strong, black line, waterproof Indian ink is a good choice. It can also be watered down for a softer grey mark.

PAPER

Different media perform better on certain papers (or supports). Fine line work, such as that produced by a pen, requires a smooth surface so that the pen can flow easily, whereas media that make broader marks, such as conté, charcoal and pastel, work better on a paper with a 'tooth' – a more irregular surface that the particles can adhere to.

The support is as important as the media, and as well as the large variety of white papers available, there are many tinted and coloured papers. Pastel papers, such as Ingres, have several subtle and tasteful shades that are harmonious with most media, not only pastels. Sugar paper is a suitable alternative.

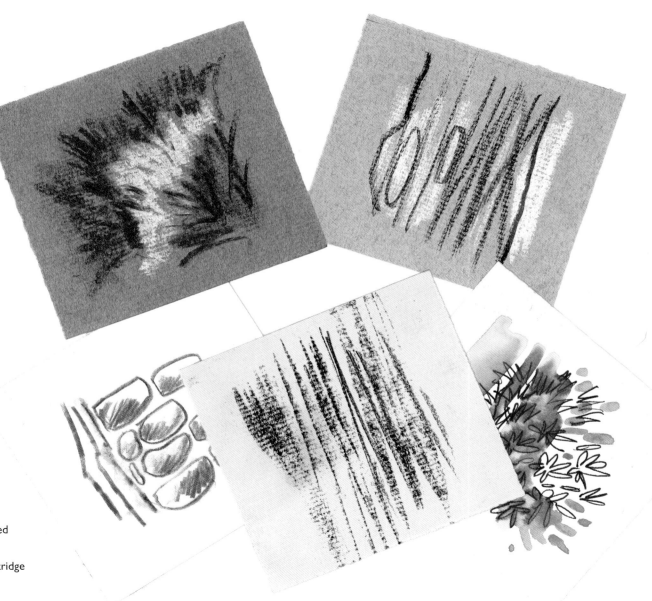

Start to combine marks made with different media to find out which will work together.

Top left Charcoal and white chalk on a tinted pastel paper.

Top right Black and white wax crayons on a tinted Ingres paper.

Bottom left Black and brown watersoluble pencils on a heavyweight cartridge paper. The pencil dissolves on contact with water.

Bottom middle Conté sticks create a lively line on a textured pastel paper.

Bottom right A dip pen line drawing with Indian ink on cartridge paper with a light wash of watercolour (see page 60).

MARKS WITH COLOUR MEDIA

Now extend your mark-making range to include those that are valued chiefly for their colour.

Use light and soft strokes as well as firm and positive marks. Try a variety of abstract marks, or use marks that suggest a mood or represent movement, perhaps an image such as the ripples of water, or the grain of wood, or the texture of grass.

Soft, or chalk pastel is a particularly versatile colour medium, capable of a wide range of marks to give interesting textural effects and powerful or subtle colour mixes (see page 80). Pastel pencils can be used on their own, or to add finer detail to pastel work.

Oil pastels can be used in a similar way to chalk pastels, and can also be blended and softened with a brush and turpentine.

Coloured pencils produce quite a delicate line, and strokes can be hatched and overlaid. Watersoluble coloured pencils can also be blended with water to achieve interesting effects.

Watercolour and coloured inks can be used with brushes and pens (see page 56).

Soft pastel gives a broad, chalky mark. Use the tip for line and the side for wider marks. Try blending and smoothing with your fingers.

Pastel pencils can create similar marks to pastels, but on a smaller scale, and they are different to handle. Try a variety of strokes, dots and dashes.

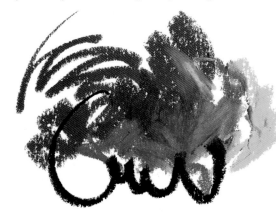

Oil pastels have a greasy feel. The colours are strong and vibrant and can be overlaid to create colour variations.

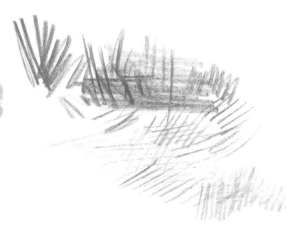

Coloured pencils can be used to create a variety of marks and can be blended and overlaid to create subtle colour variations.

Tip

The paper you use will affect the type of mark you make. The marks on these pages were made on a cartridge paper with a slight 'tooth'. Try the same marks on paper with a rougher surface and compare the effect.

Water-based media generally need a heavier weight paper to avoid cockling (or buckling) as it dries, particularly if large areas of wash are applied. Coloured and tinted papers can also be used.

Watersoluble coloured pencils are similar to coloured pencils, but they can combine the effect of watercolour and drawing if a brush is used to add water to the marks.

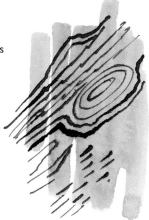

Marks made with a metal dip pen and brown ink on a nearly dry watercolour wash.

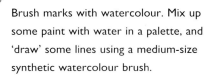

Brush marks with watercolour. Mix up some paint with water in a palette, and 'draw' some lines using a medium-size synthetic watercolour brush.

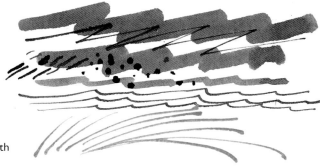

Coloured inks are used here for a variety of marks made with a brush and dip pen.

Watersoluble crayons can be blended with water. They can give expressive marks, particularly when used on textured paper.

MIXED MEDIA

Many of the media we have experimented with can be used together: charcoal can be used with pastel and with ink, pastel can be used with oil pastel or with watercolour washes, and so on. Working on coloured paper can create another dimension.

When you are starting to draw, being creative might not be so easy, but experimenting is always fun, so use your imagination to build up an image with a mixture of different materials. You may be pleasantly surprised by your results.

Top left A pale blue watercolour wash was overlaid with charcoal marks, then further dots and dashes made with a brush and blue watercolour.
Top right Watersoluble coloured crayons were used to make an initial drawing, which was softened in places with water. The point of a graphite stick was then used to make further marks.
Bottom left Lines and hatchings made with pink and mauve coloured pencils and pen and ink were followed by red marks made with an oil pastel in a similar manner.
Bottom right Pastels create an underlay of colour, its detail is smudged and overlaid with charcoal pencil.

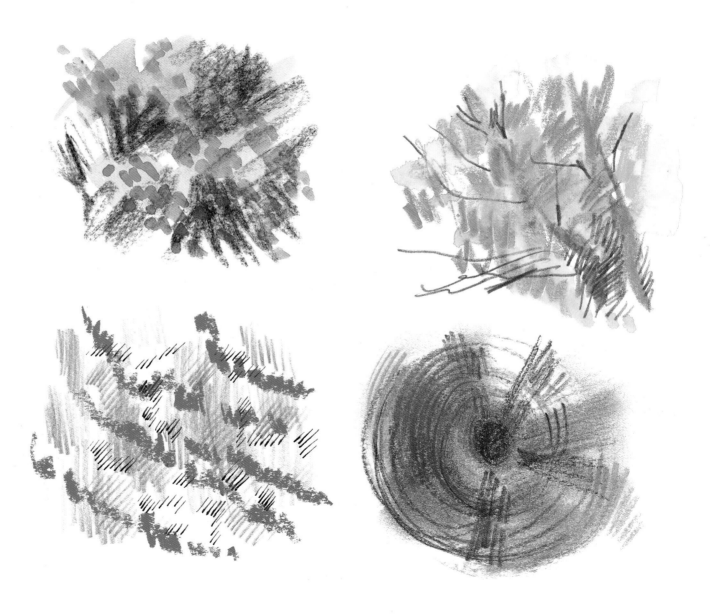

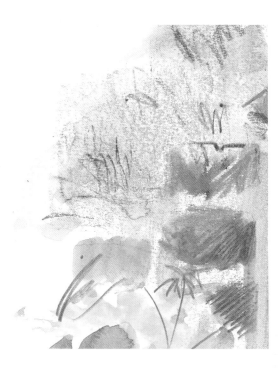

The combinations of materials and methods, and the creation of layers of marks and colour, can enrich a drawing. Colour or tonal washes of inks or watercolour (which are looked at in more detail in Lessons Five and Seven) can be useful additions to a drawing and are interesting to explore. You may wish to experiment with these before concentrating on basic drawing skills – using dry media – in the next lesson.

The illustrations on this page are details taken from the drawing on page 71. They illustrate how three different media – watercolour washes applied with a brush, watersoluble crayons (used both dry and with water to soften them) and Indian ink – were used together to create interesting and striking effects.

Several different greens were used for an underlying watercolour wash. Once it had dried, the leaves were delineated with bold marks made in the direction of the growth of the leaves, using watersoluble crayon in green and brown.

The stonework on the wall of an old building was painted with a watercolour wash and then overlaid with light marks made with a watersoluble crayon, which were softened with water. Further drawing with watersoluble crayons was made with spiky, scratchy marks to represent the texture of crumbling stone.

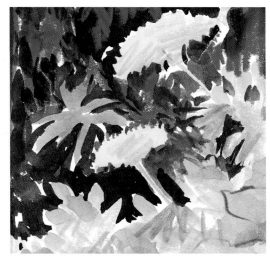

The light leaves and flowers were drawn first, using a watercolour wash and watersoluble crayon. The dark area (which in the drawing represents the shadow behind a door) was painted around the shapes with a brush and Indian ink, creating a strong contrast with the light flowers.

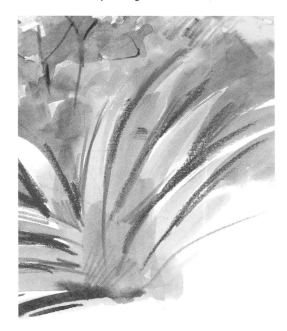

Starting Out

The first step in making a drawing that bears a likeness to an object is by really looking at that object. The next step is to transfer what you see onto paper. Start with simple objects, be optimistic and don't give up.

So, find a table and chair that you feel comfortable at, and tape or clip a sheet of A3 cartridge paper to your drawing board. Place the board square in front of you and prop it up on a couple of thick books. Find a mug or cup to draw, and place it on the table in front of you.

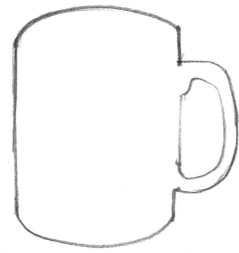

Using a continuous line, follow the outline of the mug, keeping your pencil on the paper without lifting it. Then draw the line defining the shape of the inside of the handle.

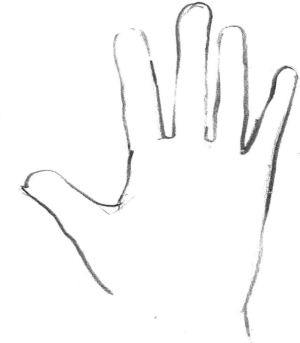

When drawing the outline of your outstretched hand, notice the angle the thumb makes to the palm, and be aware of the shapes of the spaces between the fingers.

Aims

■ To learn to look and to transfer what you see to paper with a contour drawing
■ To find the expressive quality of a line
■ To measure and construct a drawing accurately
■ To draw a group of objects
■ To draw 'negative spaces' between objects
■ To look at different views of a subject
■ To simplify complicated forms
■ To look at different approaches to drawing

CONTOUR DRAWING

There are many ways to start drawing. Contour drawing is a good way of simplifying the process. It involves following the outline of an object with your eye, and using a continuous line to put it on paper.

Start by looking closely at a simple object, such as a mug, choose a point to start at, and using a 2B pencil, take the line around the outline, ignoring any details or shapes that do not occur on the outline.

Look from the object to the paper constantly. If your lines are wobbly, or the outline strays, don't worry; start again, or correct the drawing. Notice the size of your drawing, and if it is very small, try to draw on a larger scale. It should be at least as large as the drawing on this page.

Now try drawing your hand using the same method. Hold out your non-drawing hand (in my case, my left), palm towards you, and draw the outline on the paper. Change the position of your hand (clench

Tip

Keep your pencil sharp. Preferably use a knife (rather than a pencil sharpener), which will enable you to make a long point. If you wish, make the point finer by rubbing on sandpaper.

your fist, or hold a pencil), and follow the outline, ignoring any detail that is not on the silhouette and resisting the temptation to follow the line of fingers or thumb within the silhouette.

QUALITY OF LINE

Even a simple outline of an object can express something about its shape, or texture, or the fall of light on the object. By varying the pressure of the pencil point on the paper, you can transform a uniform line, which simply records a shape, into a line that begins to describe much more.

OBSERVATION

Copy the drawing of the leaves on this page. With a subject like this, you will need to look closely in order to get it right. What kind of curve does the stem have, how are the leaves attached to the stem, where does the central vein appear on the leaf you are looking at?

Now try these exercises with other materials, conté and charcoal pencils, for instance, and see how they compare.

Keep to the outline of your hand. In some positions, the shape on the paper may be quite unrecognisable.

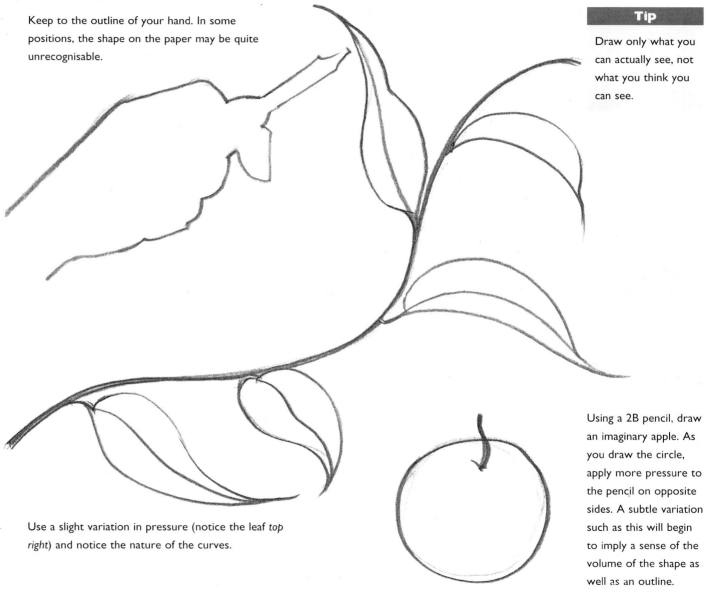

Use a slight variation in pressure (notice the leaf *top right*) and notice the nature of the curves.

Tip

Draw only what you can actually see, not what you think you can see.

Using a 2B pencil, draw an imaginary apple. As you draw the circle, apply more pressure to the pencil on opposite sides. A subtle variation such as this will begin to imply a sense of the volume of the shape as well as an outline.

MEASURING AND ACCURACY

Now that you have made a start in trying to draw an object correctly, it is time to introduce some points that will help you to reach a better result. In time you will learn to observe accurately by eye, but in the early stages it helps to rely on careful measurement-taking.

Make sure that your board is square in front of you. In this way you can use the edge of the paper as a guide for translating vertical lines onto your drawing board, with little possibility of distortion. Drawing at an upright easel makes this even easier.

You should constantly measure and compare the size of one thing to another. A useful way of doing this is to hold up your pencil at arm's length (keep your arm straight and fully outstretched). Close one eye, and take measurements on the pencil with your thumb. These measurements can be translated either directly or enlarged according to the size of your drawing. The pencil can be held vertically (as shown, right), or turned to any angle as long as it is kept at right angles to your arm.

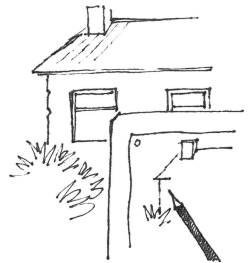

Use the edge of your board as a vertical guide.

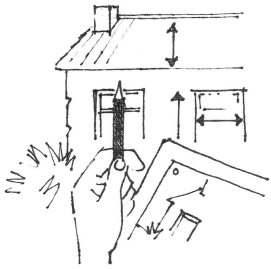

Compare the size of different elements.

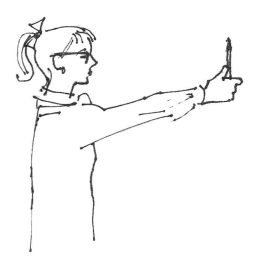

Hold up a pencil at arm's length, close one eye, and take measurements with your thumb.

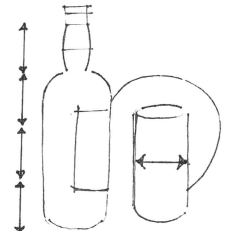

Find a unit of measurement. Here, the height of the bottle is four times the width of the glass.

Below A plumb line can be bought from a hardware store, or made by tying a small weight to a piece of string. When held up to your subject, a plumb line can be used to check verticals and to compare the positions of various elements.

DRAWING PRACTICE

Now draw some everyday objects, using a 3B pencil and A3 cartridge paper. First, copy the drawings on this page, and then draw from similar actual objects. As you draw, try to become aware of any problems you encounter, and consider the following points: take measurements to establish basic proportions of height and width; decide what size to draw at (you will naturally develop a comfortable scale at which to work); note the overall shape; look at the spaces and angles between objects. We will be looking at these points more closely in this lesson.

Remember to look backwards and forwards from the object to the drawing and do not worry if you feel the drawing is not quite right: just continue.

Review the mark-making exercises on page 15, and try making lines and curves while holding the pencil in different ways to see how this affects the character of the line of your drawing.

Hold the pencil near the point. You will find that your lines are restricted to fairly short marks. Now hold your pencil loosely at the other end (away from the point) and you will find your lines will be longer and more sweeping. Be in control, but don't hold your pencil too tightly.

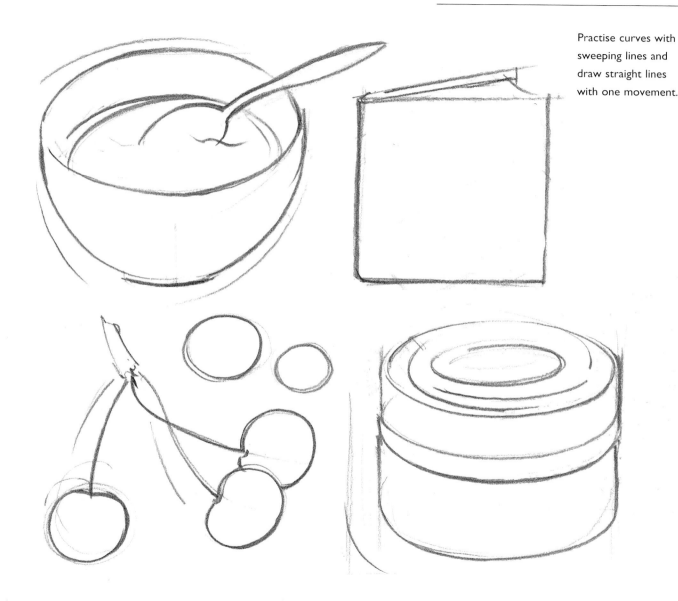

Practise curves with sweeping lines and draw straight lines with one movement.

TRANSFERRING MEASUREMENTS

When taking measurements with a pencil (see page 24) you can establish the relative proportions of an object. If you translate the measurements directly to your paper, the size of your drawing will be what is known as 'sight size'. This can be a useful way to start. If you want to work larger, you must remember to enlarge everything by the same amount, so that correct proportions are maintained.

Do not fall into the trap of drawing too small, out of fear. A larger drawing will give you more freedom of movement. It is also important to realise that the scale of your drawing will be influenced by the medium that you use.

CONSTRUCTION LINES

Having decided on the scale of your drawing, take measurements and plot out the main shapes and areas before drawing any details.

A useful way to start is by plotting a central vertical axis. This provides a construction line around which you can relate the parts of the drawing. Additional construction lines, either horizontal or at an angle, will help you to position different parts of the subject accurately in relation to one another.

DRAWING A JUG

Now attempt to make an accurate drawing of a single object using observation, careful measurements and construction lines. For this drawing you will need: an A3 size sheet of cartridge paper, a 2B pencil, an eraser.

Sit with your drawing board propped up on a table. Place a jug or vase similar to the one shown (a glass object will help you to understand the form even more clearly) on the table close in front of you. Before you start drawing anything, describe the jug to yourself in detail, and draw it in your mind's eye.

Looking slightly down onto the jug, the circular opening will be seen as an ellipse, or compressed circle. Practise these shapes before you start the drawing (see opposite).

Now begin to plot the proportions of the jug on the paper, using construction lines. Draw the shapes lightly, so that you can change them if they are not right before strengthening the lines.

Right Draw a vertical centre line, and measure the width of the jug in relation to the height. With horizontal lines, mark the centre of the ellipses at the top and bottom, and at the widest point of the jug. Draw the ellipses lightly, continuing the line all around the shape, even if it is not visible.

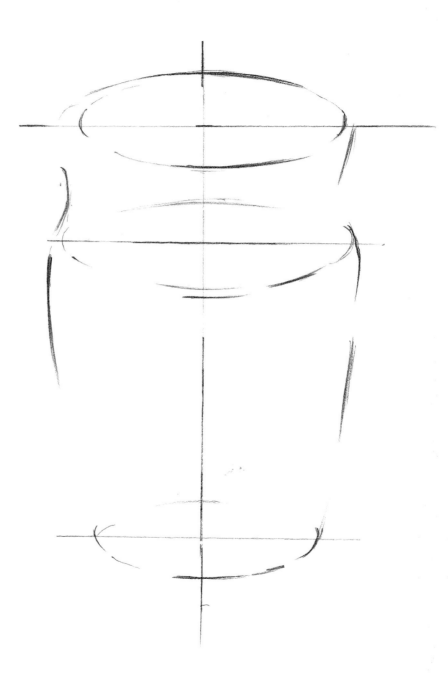

Note the thickness of the rim of the jug. Draw the lip, imagining that you are the potter, pulling out the clay, or that you are pouring water out of the jug.

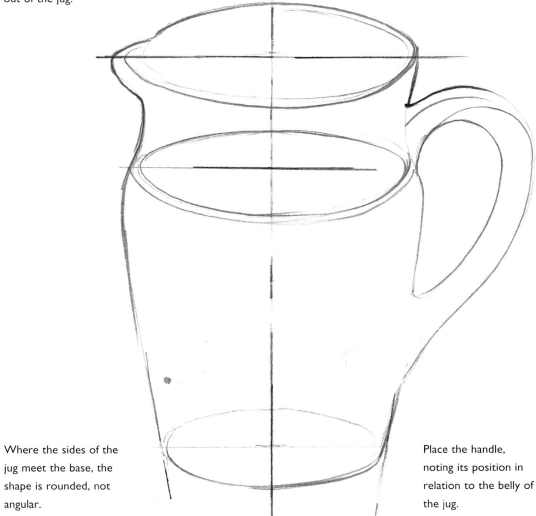

Where the sides of the jug meet the base, the shape is rounded, not angular.

Place the handle, noting its position in relation to the belly of the jug.

An ellipse is a circle seen from an angle. To simplify these shapes, first draw them freehand in one swoop, letting your hand travel over the paper freely without stopping.

For greater accuracy, start with a central vertical and horizontal line. Draw the bottom half first, then the top, keeping the sides well rounded.

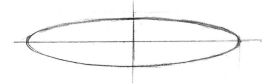

Where the sides meet the top or base of a cylinder, the shapes are usually rounded.

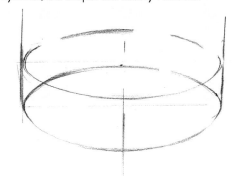

If you move away from your drawing position, remember to go back to exactly the same spot, or your view of the subject will change.

If you have to put the object away, first draw around the base so that you know where to position it when you return it to the set-up in order to continue.

DRAWING A GROUP OF VEGETABLES

In the drawing of a single object (such as the jug on the previous page) you have found that the relation of one point, line or shape to another is important to the accuracy and harmony of a drawing. This relationship is developed when a group of objects is depicted. In this exercise we look at plotting the shape and position of a group of vegetables in relation to one another, and make a line drawing that accurately defines the visible contours.

Make your own arrangement of assorted vegetables on a piece of plain paper on a table against a plain background. If the background is distracting, place a piece of card or hang a cloth behind your group to obscure it. You will need a sheet of A3 cartridge paper and a 2B pencil.

Start by looking and really seeing. Note the shape and texture of each object, then imagine drawing them.

Make one or two thumbnail drawings of the subject, approximately 9 x 6cm (3 x 2in). These preliminary small-scale drawings will help you to understand what you are looking at, and to establish how the group should be placed on the paper.

Then, start to draw the vegetables at actual life size, or slightly smaller, taking measurements to establish proportions.

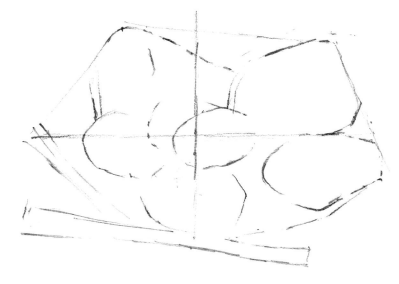

STEP 1

Note the highest and lowest points, and the centre of the group. Draw vertical and horizontal central construction lines.

Consider the overall irregular shape of the group. Begin to plot it out on the paper and start placing everything, working over the whole group, using dots or lines to indicate the position of the vegetables. Find the line that defines the outside shape of the whole group.

Draw very lightly so you can correct your mistakes easily and feel your way into it before you make more positive lines.

STEP 1

Determine the vertical and horizontal centre lines of the group, and mark these on the paper. Lightly mark the overall shape of the group on the paper. Begin to indicate the individual shapes and positions of the vegetables.

STEP 2

Consider the size of one vegetable to another, and continue lightly drawing the shapes. Do not concentrate on one particular part. Where shapes overlap draw the whole shape, even if it is not visible, if this helps the flow of your drawing. Note the spaces created between the vegetables, correcting and adjusting as you go.

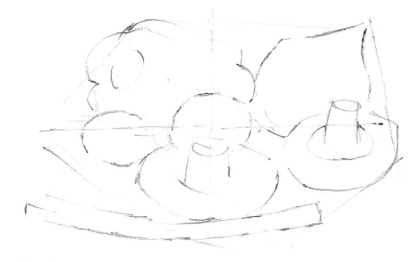

STEP 2

STEP 3

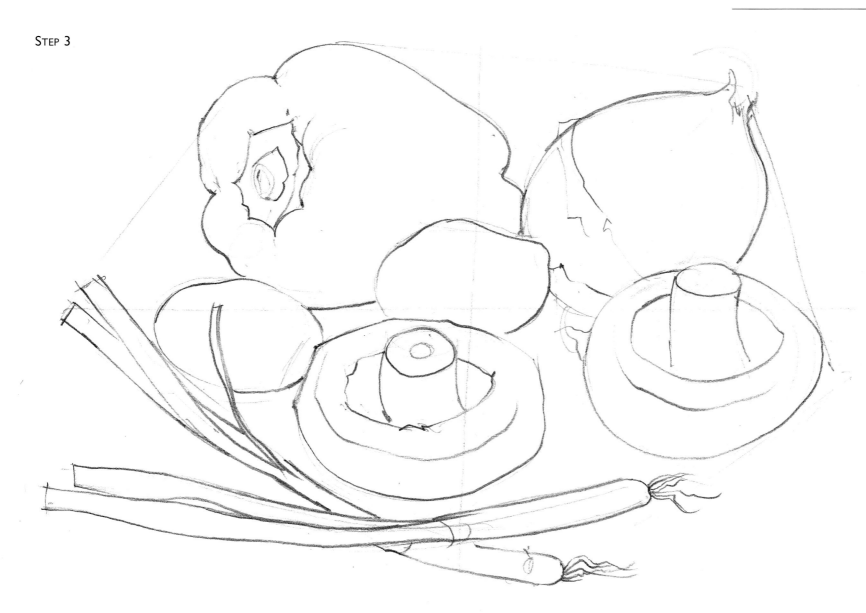

Keep your marks very light until you are satisfied with the shapes you have created, checking across the drawing to see that all parts relate correctly. Take as much notice of the shapes created between the objects as the objects themselves.

Once you have made some progress, get up and walk around, then look at your drawing with a fresh eye. Correct any parts if necessary before firming up the line.

Tip

Construction lines often contribute to the liveliness of the drawing. If you wish to remove them, take care not to disturb the surface of the paper by erasing too freely.

NEGATIVE SPACES

It is important to look for clues that will help you to draw more successfully. The relation of parts of a single object, and of one object to another, gives an understanding of what is going on, but it is all too easy to concentrate on looking at the shapes themselves, without noticing the shapes of the spaces around them.

These shapes are called 'negative spaces'. Drawn correctly, the shapes of these spaces are as important as the objects themselves, and they will help you to achieve greater accuracy in your drawing.

DRAWING 'NEGATIVELY'

Drawing only the spaces around a subject requires you to adjust your way of looking. Choose a subject, such as the leaves on this

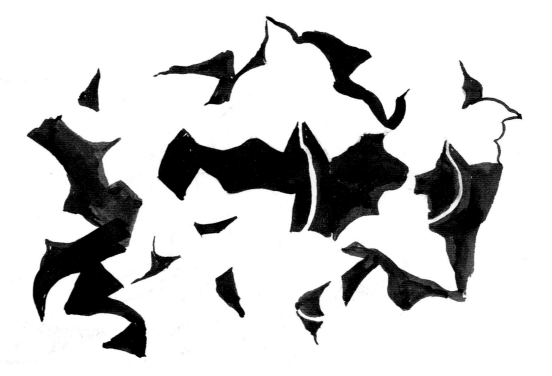

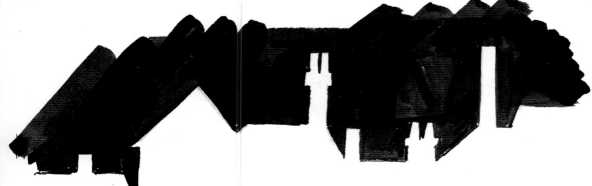

page, or a tree as on the opposite page. Spend some time looking at your subject, and then begin to record the areas between the objects. Do not draw to describe the outlines of the objects themselves but to describe the spaces between them.

Move from one space to an adjacent one, noticing their position in relation to one another. Slowly your picture will begin to build up, and the spaces representing the objects will be revealed. If lines or

The painted spaces between these ivy leaves say just as much about the appearance and character of the leaves as would a drawing of the leaves themselves.

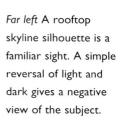

Far left A rooftop skyline silhouette is a familiar sight. A simple reversal of light and dark gives a negative view of the subject.

curves do not connect in the way they should, do not be discouraged; start again or correct your drawing until you are satisfied with the result.

Most drawing media are suitable for this type of drawing. On the opposite page Indian ink has been used with a brush, the black and white giving maximum tonal contrast, but not much room for error. A soft pencil was used for the drawing on this page, which allows for shading to be altered if necessary.

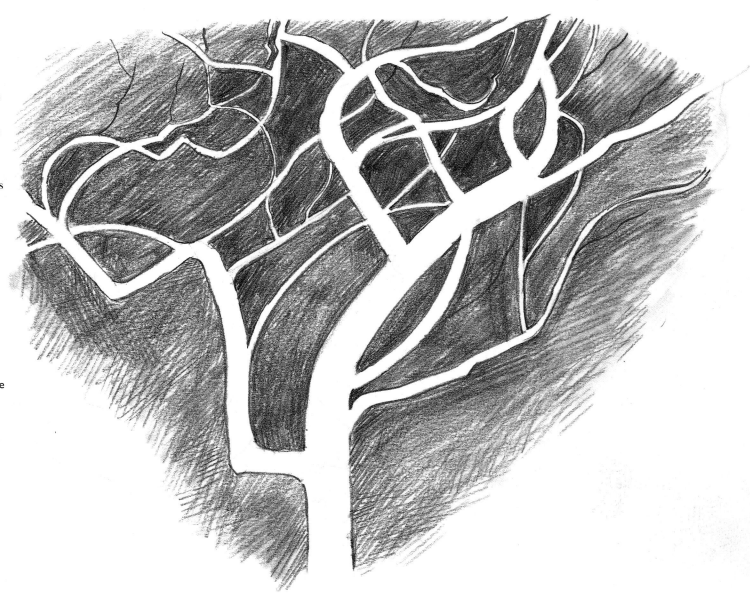

Drawing the spaces between the branches of a tree in winter is an interesting exercise. Find a suitable subject (perhaps a tree that you can see from a window) and look hard at the shapes created against the sky. Force yourself to look at the shapes between the branches rather than at the branches themselves and use a pencil to shade those areas. This can be easier to see if you draw at twilight when the definition of the form and details of the tree are less distinct and distracting. As you draw, you will also become aware of the decorative nature of the patterns that are made.

CHANGING THE VIEW

Objects that are familiar to us often take on a completely new appearance when we see them from other angles. Also, with everyday objects we have fixed images of them in our minds, which can be quite difficult to depart from.

Drawing something from more than one angle, or from an unusual angle, can be an exciting adventure. It will help you to understand the object as something solid, and you find that as soon as you change your viewpoint, edges, proportions and shapes change considerably.

Whatever your view of a subject, work in the usual way: measure length to width, decide on a centre line and plot any construction lines, look for the shape, get your proportions right and start drawing.

DRAWING SHOES

For this exercise draw from real objects; do not copy from the drawings. Use a pair of shoes as your subject (I used a pair of trainers). Feel them, ask questions: what shape are they, what are they made of, are they rigid or soft?

Set them up near you to give you a side view (the easiest and most obvious way); look at the shape; are they contained in a rectangle? Put in a centre line, measure the height to the width, and get the proportion right. You might be quite surprised by the proportions. Start drawing the outline by looking at the general direction of the edges. I find it easier to start by using fairly straight lines. I then curve them and put in

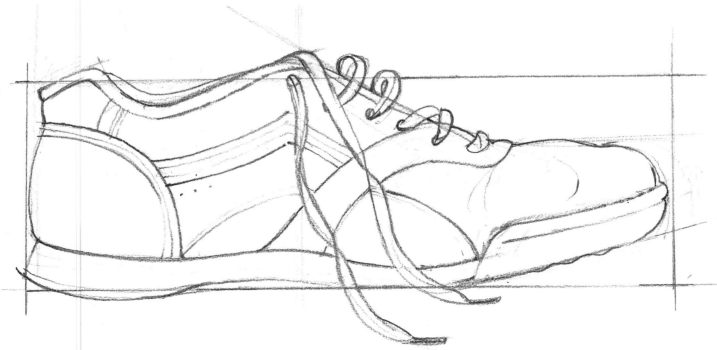

Side view of shoe. This is most people's notion of a typical view. Do not let familiarity lead you to assume anything about the shape.

Tip

On a rounded surface, the eye sees an edge where the surface goes out of view. Change your position even slightly and this 'edge' will move too.

Back view of shoe. The heel is large, the toe small. Check parts through the whole shape on a vertical construction line. Its outline would be hard to identify without the details of the drawing.

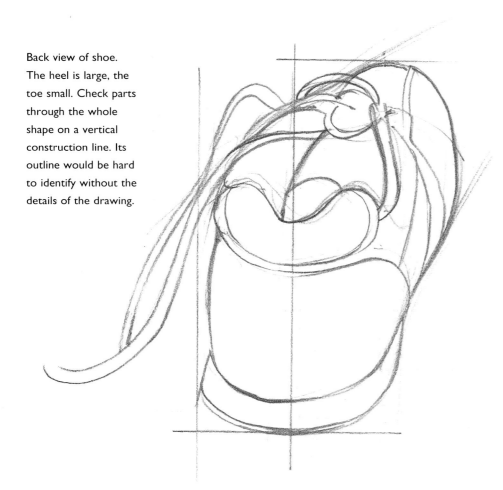

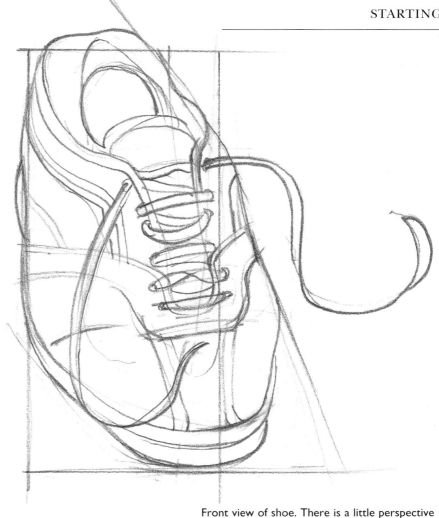

Front view of shoe. There is a little perspective here (the furthest part of the shoe becomes smaller) but as long as you get the shape right you do not need to worry about it. A wedge shape can be used as the basic form; the vertical centre line goes up through the laces. The heel, now furthest away, is much smaller.

more detail later. Lastly, have fun putting in the detail of stitching and the laces.

Now turn the shoe towards you or away from you, slightly at an angle. Draw accurately and you will not have to work out any problems of perspective. Measure the width to the height; notice the overall shape, choose a vertical line and plot the position of any shapes on it. Draw with sweeping lines to follow around the shape.

33

IMPOSING A STRUCTURE

Construction lines have been used in this lesson to give you a reliable point of reference for your drawing. Solid objects such as bottles, pots, jugs and shoes can be measured and divided up conveniently and drawn more accurately. For more ephemeral, delicate and amorphous objects, such as leaves and flowers, construction lines and basic geometric forms can be imposed upon a shape to clarify understanding of them.

LEAVES AND FLOWERS

Leaves on a stem make a random shape, giving a subject that is at first difficult to plot. If you can contain the leaves within construction lines, these will help you to keep the outer points within the right area, and they will give points of reference for the position of elements. Note the number of leaves and the way the leaves behave. Draw and re-draw until you get it right; don't worry how many lines you put in, you will find the right one! Look at the negative spaces in your drawing too (see pages 30-31). When you have checked your drawing, give it more definition and put in more detail.

When drawing flowers, identify the basic underlying geometric shape first – a cone, cylinder or circle, for instance. Then draw

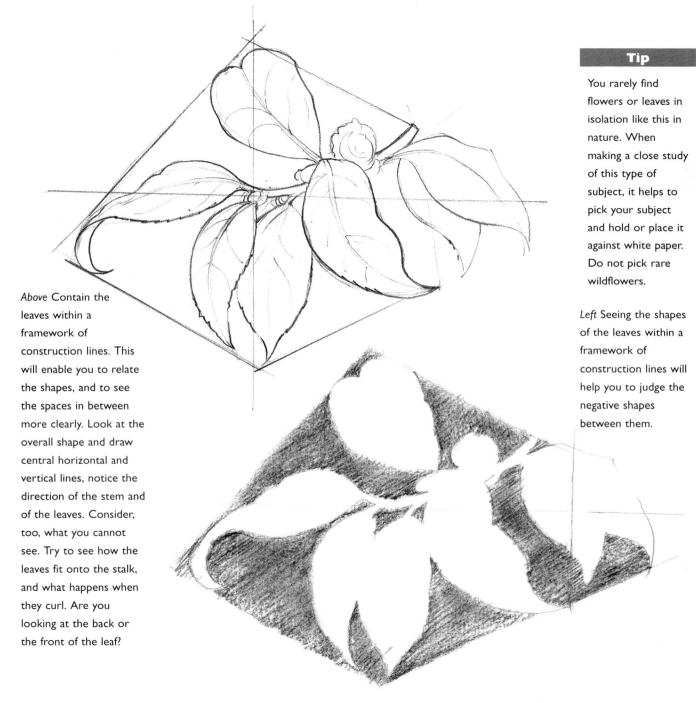

Above Contain the leaves within a framework of construction lines. This will enable you to relate the shapes, and to see the spaces in between more clearly. Look at the overall shape and draw central horizontal and vertical lines, notice the direction of the stem and of the leaves. Consider, too, what you cannot see. Try to see how the leaves fit onto the stalk, and what happens when they curl. Are you looking at the back or the front of the leaf?

Tip

You rarely find flowers or leaves in isolation like this in nature. When making a close study of this type of subject, it helps to pick your subject and hold or place it against white paper. Do not pick rare wildflowers.

Left Seeing the shapes of the leaves within a framework of construction lines will help you to judge the negative shapes between them.

this shape lightly (I have emphasised it in these drawings; they would normally be much fainter), before drawing the details, building them up on the basic form.

If you feel you have made a mess of it you can start again, or if your construction lines are incorrect go over them or make new lines. I find that getting up and walking away, and then returning to my drawing, helps me to look with a fresh eye.

Some artists say that the only way to understand what you see of an object is to draw it. You will know the leaf stem a lot better once you have drawn it. It also helps to be able to identify the parts of a flower: the sepals, stamens and pistil as well as the petals. Refer to books on botany, or collect gardening catalogues, and gather as much reference as you can if you become interested in flower drawing.

Try different media to find which suits you and your subject best. Any medium that will give precise detail will be suitable. You will find examples of pen and ink and coloured drawings in Lessons Five and Seven.

The daisies (*top*) are fairly simple shapes – circles and ellipses. The two trumpet-shaped flowers are based on cone shapes. Establish a basic geometric form and draw it lightly before putting in any detail. Count the petals and make sure that they are arranged correctly.

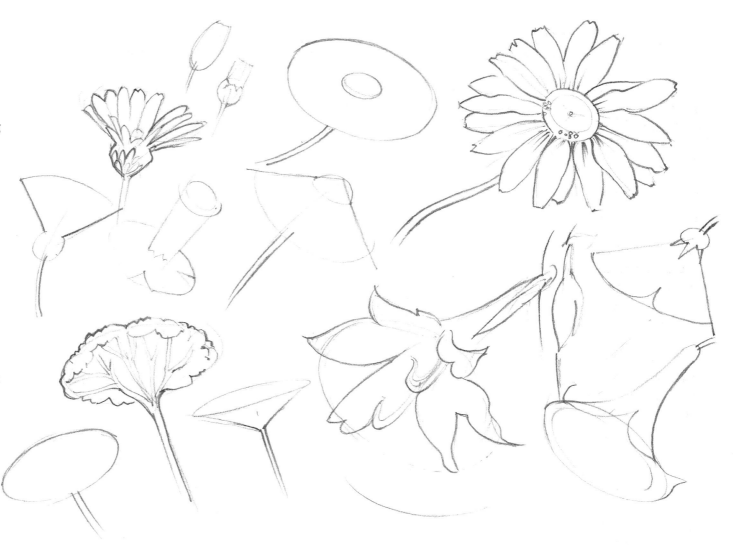

APPROACHES TO DRAWING

As you work through the exercises in this book I hope you are finding that your powers of observation are becoming sharper and that your drawing skills are improving and becoming more varied.

In this lesson you have learnt how to represent objects on paper. As you progress you will begin to think more about what you are actually trying to achieve with your drawing. Use a sketchbook as much as you can to help you develop your drawing.

You will discover what appeals to you about drawing, and begin to put something of yourself into your work. With practice, you will begin to develop your own 'handwriting' – a way of drawing lines and making marks that feels natural to you. You will also begin to discover what scale you feel most comfortable working at. I have recommended A3 size drawing paper, but perhaps A2 or even A1 size paper would suit you better if, in time, you find that you like to work boldly on a large scale with big pieces of charcoal.

Your method and approach to drawing will come from within yourself as a response to a subject or a mood. So try to find a way of expressing the subject appropriately. Drawings are made for many different purposes, in response to different demands. A variety of approaches can be adopted to suit the demands of the situation and what you want to express.

Contour drawing is a technique that you have already encountered. It is a very useful way of training your eye to appreciate the shape of objects.

Drawing can be used to record a subject with a scientific approach. Botanical and archaeological drawings must be highly

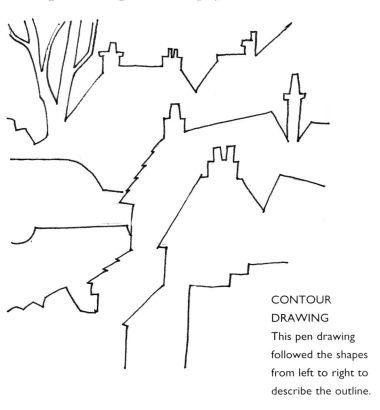

CONTOUR DRAWING
This pen drawing followed the shapes from left to right to describe the outline.

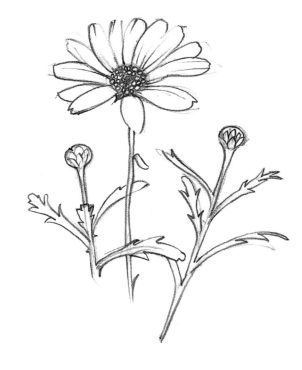

RECORDING
A botanical drawing that records the details of a flower, drawn with a B pencil.

accurate, detailing with precision the features of the subject, be it a flower, a mushroom or a flint arrowhead. Maps and architectural drawings also fall into this category. Precise media, such as pencil or pen and ink are often suitable for this type of work.

Expressionistic drawings convey the artist's response to a subject and say something about his or her feelings about it. A drawing might convey the mood of a stormy sea, or capture with a fleeting

gestural line the speed and graceful movement of an athlete. It may be inspired by the imagination or a feeling triggered by your response to a subject. The medium chosen will play an important part in this type of drawing.

Accidental drawing is something that many of us do while doodling. Marks and images come from the unconscious to surprise us. Do not dismiss these as possible starting points for your work.

ATMOSPHERIC DRAWING

It was the mood of the scene that inspired this drawing (made with a 6B pencil), rather than a desire to record it accurately and in detail.

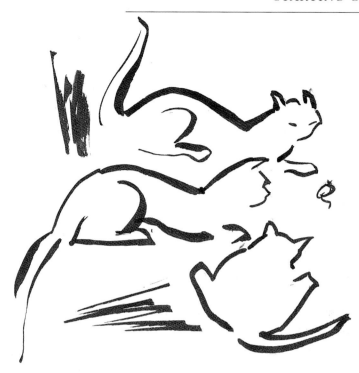

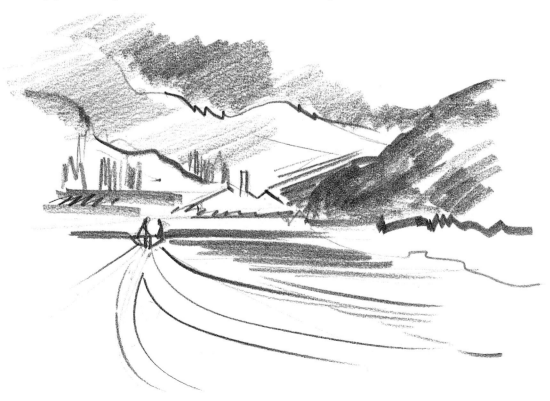

EXPRESSIONISTIC DRAWING

A swiftly made brush and ink drawing of cats attempted to capture the movement of these animals.

Tip

Studying the work of other artists will teach you a lot. Look at the work of the Old Masters and of contemporary artists – notice their subject matter, the way they use line, and the character of the marks they make on the paper, the mood of the drawing and the effect that it has on you. What do you like, and what do you not like about the drawings? Try copying a drawing that you like in order to find out how it was put together.

Tone

Line can be used to describe the shape of an object, and that line can be varied in intensity to suggest the fall of light on an object. By adding tone, a drawing is more fully fleshed out to describe the effect of light and dark, volume and form, thereby giving more meaning.

Tones can be seen more easily if we look through half-closed eyes. This makes detail and colour disappear.

In this lesson we will be looking at ways of conveying tone in terms of black and white and the range of greys in between. It is important to understand this before working in colour (which also has tonal values – see Lesson Seven). This lesson concentrates on using dry media; drawing with tonal washes is explored in Lesson Six.

Aims

- To understand why tone is used and how to apply it
- To make a tonal scale
- To use tone in a drawing to render the appearance of volume
- To look at different types of light

RENDERING TONE

There are many ways to indicate tone and to work from one tone to another.

Blended shading is smoothly graded and achieved by making closely worked strokes or by smoothing with the finger or a torchon.

Stippling is a method that uses dots of different sizes and density. It is often used by illustrators, and is quite labour-intensive.

Blended shading with charcoal pencil.

Stippling with pen and ink.

Hatching and cross-hatching with pencil.

Hatching is created by a series of parallel lines. These can be overlaid by other lines at a different angle, creating cross-hatching. These lines can vary in character, density and direction, but they should have a purpose and be arranged in a way that contributes to the description of the form as well as the tone. They are a deliberate way of working that should not be confused with scribbling, which can be careless.

Tip

A torchon or tortillon is a pencil-shaped roll of paper that can be used for blending and shading small areas.

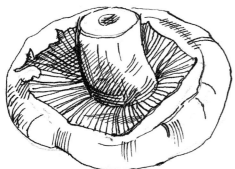

Left Pen and ink line delineates the gills of the mushroom, and the hatched marks describe the roundness of the stem and the areas of shadow.

Right Charcoal offers a wide range of tonal description. Light tones are blended with a finger and heavier marks are overlaid, also adding texture. The contour line of the potato also suggests the fall of the light.

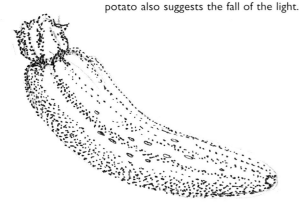

Stippled marks made with pen and ink are denser in the shadow areas. Draw the shape lightly with pencil first.

Varying pressure on the pencil line gives an impression of light and shade, and light hatching gives volume to this onion.

USING A TONAL SCALE

A tonal scale is a useful device for keeping track of the tonal values in a drawing, particularly with more complex subjects such as landscapes, where detailed areas must be seen as part of a broader area of light or shade. Determine the darkest and lightest parts of your drawing, and make a tonal scale of about five tones in the margin. Use this as a constant check as you draw, comparing tones to judge their relative values.

A tonal scale should be made with whatever medium you are using (and using the same mark-making technique).

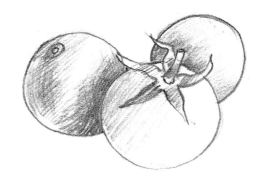

Pencil shading and cross-hatching is used to give tone and shape. With the light coming from the right, the tomato in front throws a shadow on the two behind.

TONAL SCALE

As an exercise in controlling tonal gradation, make a scale divided into ten parts. Work from black to white, shading with a soft pencil, gradually and evenly increasing the intensity of the shading.

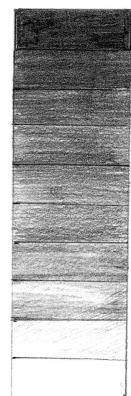

Right Tone has been created with pencil hatching to describe the form of this tin and the shading created by the light (which is falling on the right of the tin, creating a shadow on the opposite side). The shading changes gradually in intensity to suggest roundness. First, hatched lines were made diagonally in one direction; these were intensified by diagonal lines in a different direction; finally, vertical lines were used to give the smoothness of the surface.

Below In stippling this green pepper, single dots were used to describe the shape initially. The density of the dots was then increased to create areas of tone in high contrast.

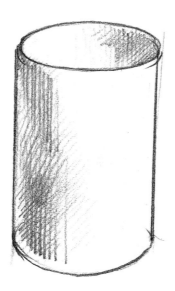

Below Washes of ink give interesting tonal effects (see page 60). For this pear, ink washes of different dilutions were used, with each wash being allowed to dry before applying the next. With white paper left to represent the lightest parts, the first wash was very light, the second a little darker, and finally a dark wash was applied to the shadowy area at the bottom.

TONE AND FORM

The way tone is used to render light and shade on an object will give clues to form. On a cylindrical object, for instance, the tone moves gradually from light to dark, following the gently curving form. On a form with sharp angles, light and dark areas are more sharply contrasted.

To investigate this, set up some simple objects (tins or vegetables, for instance) in differently lit situations, with light at different angles, and different intensities, and try to identify areas of light and dark and mid-tones, and notice how they change as the light changes. You will see that the light also casts a shadow from the object onto the surface it is standing on (see page 46).

CREATING TONE

Now find out how much you have observed by making a tonal drawing from the imagination. A fish makes an interesting subject – invent your own or use the drawing on the opposite page for reference. Use a 4B pencil, and a sheet of A3 paper.

Invent your own light source and imagine how it would affect the subject. Find different ways to indicate light and

shade to express the roundness of the fish. Try cross-hatching (as shown), blending or stippling, or perhaps a mix of these methods. Also try different media.

STEP 1

Draw the basic shape of a fish and any details, such as scales and fins, using line. Identify a light source (here it is from above), and imagine how the light would fall on the object.

STEP 2

Start to hatch the areas that would be in shade, taking the lines around the shape of the fish, imagining the roundness of the body, as if you were drawing lines around the fish itself.

STEP 3

Use cross-hatching in a different direction to darken the darker areas. Build up areas that vary in intensity; keep light areas light. Markings can also be indicated by tone once the general areas of light and shade have been established.

Tip

If your drawing smudges, place a piece of paper on the drawing under your working hand.

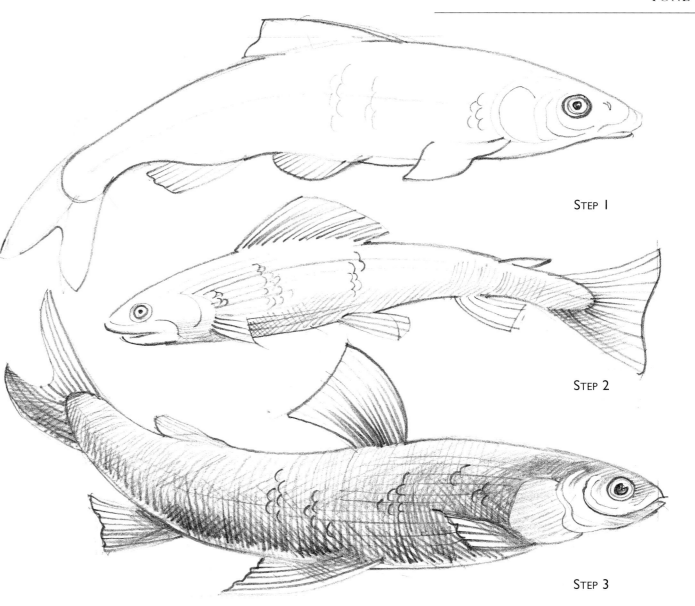

STEP 1

STEP 2

STEP 3

41

WORKING ON A LARGE SCALE

It is helpful to enlarge your subject and work on a large scale when you are trying to understand the tones created by the effect of light. Natural objects, such as the dried seed heads of flowers and nuts, provide interesting subjects for this type of approach.

Have your subject very close to you when you are drawing (you could put it on your board). You can enlarge the object by eye, or take a height and width measurement from it, and double or triple it, then plot the main shape on the paper, using construction lines if necessary.

It is important to draw as accurately as you can when working on a large scale as mistakes are more obvious. You will be forced to observe your subject closely and to be decisive about how you render tone.

USING CHARCOAL

The shape of the dried poppy seed heads makes a fascinating subject for a charcoal drawing, using the point of a thin stick for the fine lines and the side of the stick for broader lines. Charcoal can be smudged and blended to give subtle shading in a range of greys, and excess charcoal can be blown away. Areas can be rubbed off and worked into afresh.

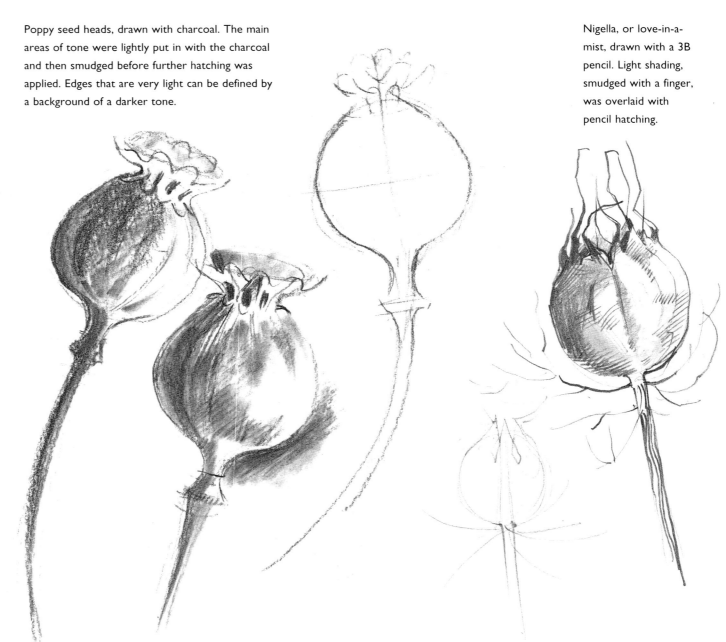

Poppy seed heads, drawn with charcoal. The main areas of tone were lightly put in with the charcoal and then smudged before further hatching was applied. Edges that are very light can be defined by a background of a darker tone.

Nigella, or love-in-a-mist, drawn with a 3B pencil. Light shading, smudged with a finger, was overlaid with pencil hatching.

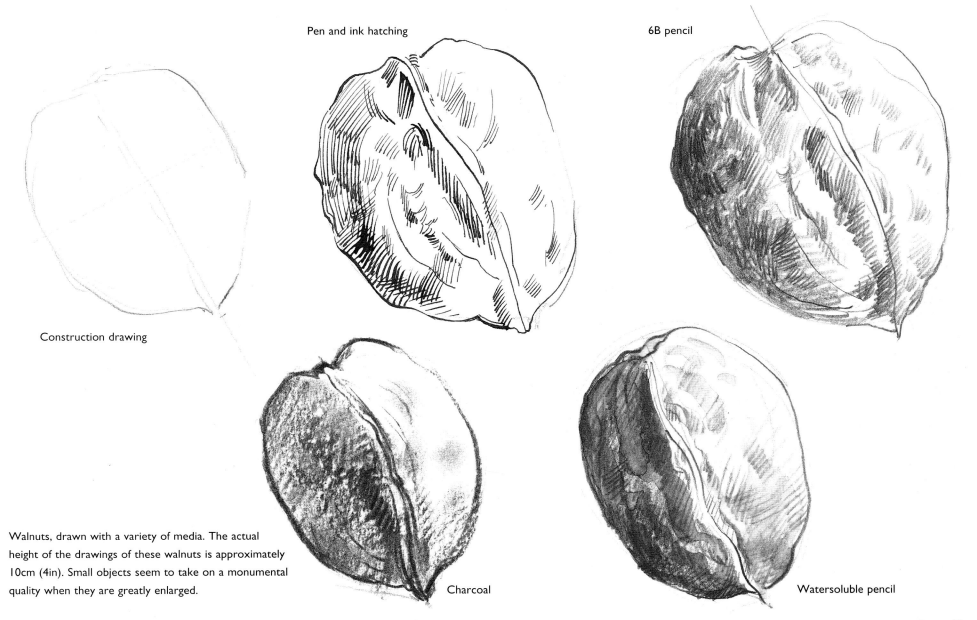

Pen and ink hatching

6B pencil

Construction drawing

Charcoal

Watersoluble pencil

Walnuts, drawn with a variety of media. The actual
height of the drawings of these walnuts is approximately
10cm (4in). Small objects seem to take on a monumental
quality when they are greatly enlarged.

WORKING OUT OF CHARCOAL

Charcoal can be used for an interesting drawing technique that is useful for a broad, bold approach to establishing large areas of tone. In this exercise, rather than working from the white paper towards the darkest tones, you start with a mid tone, and work towards light by erasing the charcoal, and towards dark by building up tones.

This is a very effective technique if you find it difficult to work tonally because it allows you to concentrate on recognising the darkest and lightest tones first. The intermediate greys are then easier to see as you have already established them in broad terms, making the addition of details an easier task to perform.

To try out this technique you may wish to follow the example in the book, to copy from a black and white photograph of a scene, or to invent your own imaginary landscape. For this drawing you will need: a sheet of A3 cartridge paper or sugar paper, charcoal stick, putty rubber.

This way of working in charcoal is ideally suited to landscape, and there is another example on page 70. However, it is equally effective for other subjects such as still life, figure drawing and portraits.

Tip

Cut up or tear your putty rubber into small usable pieces. When a piece becomes saturated with charcoal, throw it away and use a new piece.

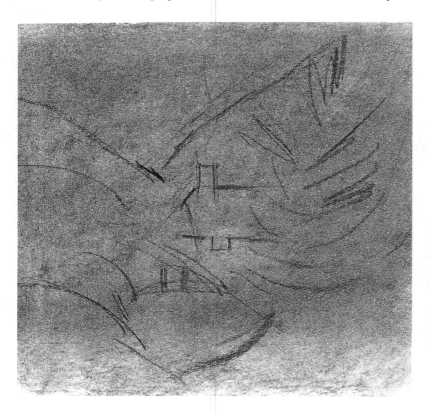

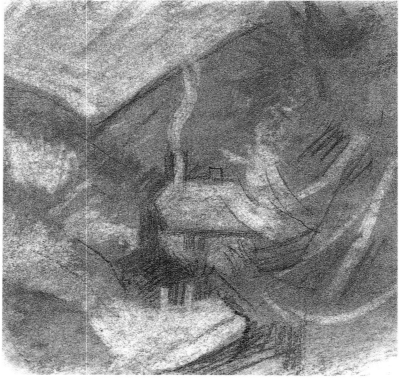

STEP 1 (*far left*)
Decide on the format of your drawing, and rub over the whole area with the side of a piece of charcoal. Rub with a tissue to make an all-over grey tone. Blow the dust off. Draw in the image with the point of the charcoal stick.

STEP 2 (*left*)
Use a putty rubber to take out the lightest areas, then place your darkest tones. You have now established areas of the darkest, medium and lightest tones.

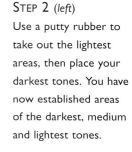

STEP 3

Now put in details, using high-contrast linear work in the foreground (with the point of the charcoal and the putty rubber). Background areas are less defined, giving a sense of recession. These broad tonal areas also provide a foil to the lighter tones of the cottage. Last of all – and for fun – use a putty rubber to create the smoke coming from the chimney.

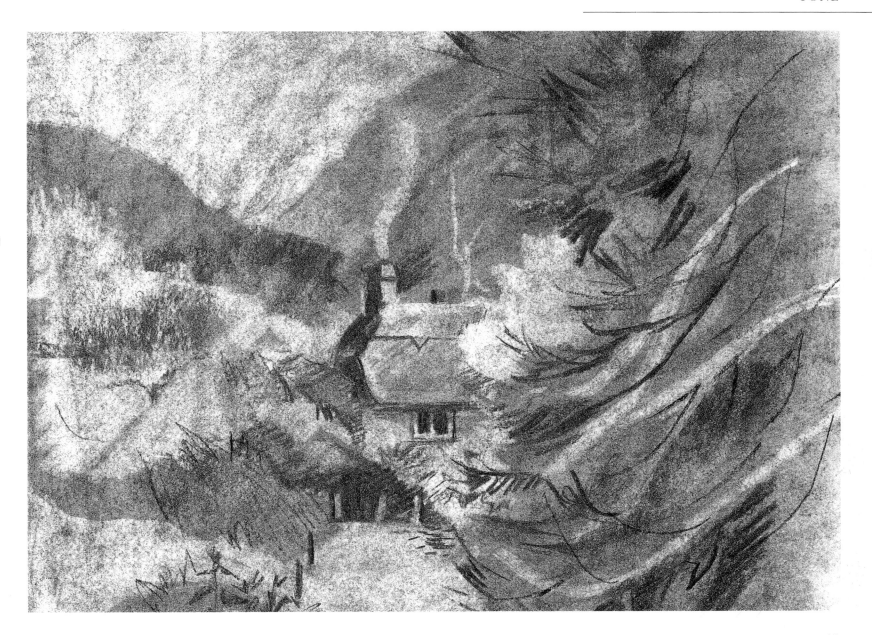

LIGHT AND SHADOWS

The nature of the light falling on an object can create tone of varied character. A diffuse, misty grey sky, for instance, will cast gently modelled tones, with no extreme contrasts of light and dark, while objects seen in the full glare of a spotlight or raking sunlight will be sharply modelled in tones of high contrast.

If the light is strong enough it will also throw shadows from objects in its path. These not only help to describe the form of the object but can also create interesting shapes and patterns in a drawing. Notice how important the shadows are to the drawing at the top of this page, and imagine how different it would be if it had been drawn on a grey, sunless day.

Try to draw as many situations involving shadows as you can, keeping a record by means of sketches, notes or photographs. Observe shadows accurately – drawn incorrectly they will confuse the viewer. When well observed, shadows can often transform a very ordinary scene into a dramatic composition.

ANGLE OF LIGHT
The shape of a shadow is altered by the angle of the light source on an object. Observe this yourself by illuminating an

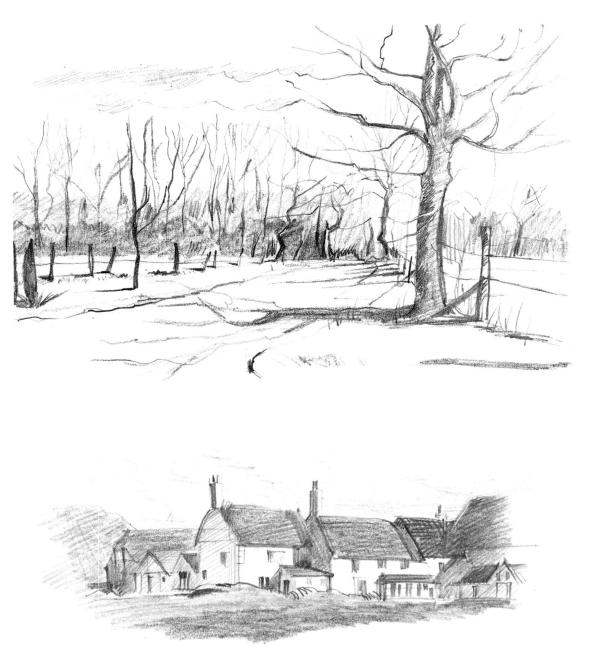

The pencil sketchbook drawing of these bare trees is made more interesting by the patterns created by the long shadows cast by the low winter sun.

Shadow falls on the sides of these cottages, making an image of high contrast. At a different time of day the shadows might not have contributed so well to the drawing.

46

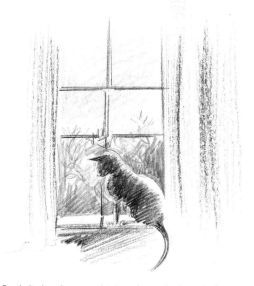

Back-lit by the sun shining through the window, a halo or rim of light appears on the cat's back, and a strong shadow is cast by its body.

object with a spotlight or table lamp held at different heights. Notice that the area of shadow cast by the object is usually the darkest tone, and also (obviously, but importantly) that the cast shadow is attached to the object itself.

In artificial light, the light can be controlled, but remember if you are working outside, or dependent on natural light, that the sun moves across the sky during the day and your shadows will be constantly on the move. The sun is higher in the sky at midday, and so casts shorter shadows than early and late in the day, when the sun is lower and shadows are longer.

BACK LIGHTING

If an object is viewed against the light, that is, with lighting behind it, it will become silhouetted. If the lighting is strong, a rim of light is created around the object creating shadow areas of high tonal contrast. Try this for a dramatic treatment of a portrait, placing your sitter against a brightly lit window.

REFLECTED LIGHT

Light can be reflected indirectly from one object to another creating complex areas of tone. Shiny objects are more likely to show reflected light, but other surfaces can as well. When drawing objects with shiny surfaces, look very closely at the shadow and the shapes of the areas of reflected light – you may be quite surprised at what you find.

Many lights are reflected in the pink jar, which in its turn is reflected onto the shiny surface of the white cup.

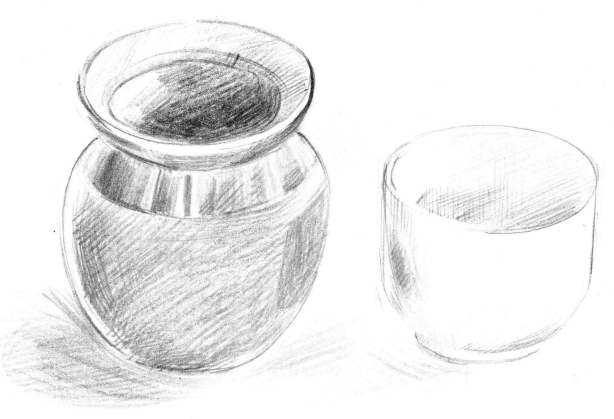

Texture and Pattern

The texture (or 'feel') of an object and the surface appearance of patterns and marks add to both the descriptive and evocative quality of a drawing. In this lesson we will explore how marks and tone can be used to create effects to describe different surfaces, and I will introduce you to some interesting experimental techniques. You will also discover how the character of the marks you make can affect the atmosphere and mood of a drawing.

Texture can also be used to help to define space in a picture: the texture of areas in the foreground can be treated in detail, contrasting with areas that are further away and less well-defined.

Aims

- To explore a range of marks and tools to render different textures
- To judge when the use of texture is appropriate
- To think of texture as a means of defining distance
- To consider atmosphere and mood
- To explore new techniques

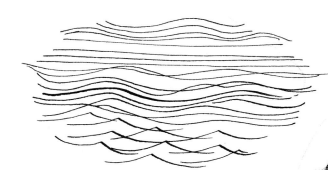

A fine pen and Indian ink is used to denote water: choppy broken lines in the foreground, more flowing lines in the distance.

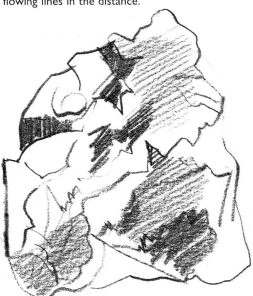

The jagged facets of a piece of stone are depicted here with conté pencil.

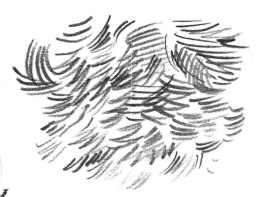

Vigorous short marks with a 4B pencil denote different directions of growth in the rough fur of a dog.

Left Charcoal pencil traces the pattern of wood grain, and smudging gives tonal variety.

From a distance, leaves and flowers are seen in terms of generalised masses of shape, tone and colour.

RENDERING TEXTURE

Often the way in which you draw unconsciously indicates textural qualities, whether those qualities are real (for a realistic representation), invented (to contribute to the meaning of the drawing) or exaggerated (to emphasise certain areas and increase the textural feeling and interest in the drawing).

When you are drawing, look closely at your subject and respond to it sensually. Feel the roughness of tree bark, the jaggedness of rock, the softness of fur, the shiny smoothness of glass. Ask yourself how you can best represent the textures. Should you use soft sinuous pencil lines, or short, stabbing lines with the pen, for instance? It is important to consider the medium, the individual marks, and the way you mass the marks together. Compare the different treatments of the texture of feathers on this page – there are always many ways to interpret a subject.

It is not necessary to describe texture fully over the whole area. Be selective and allow other areas to be explained by implication (see example, bottom right).

Be prepared to make your own experiments and build up a bank of ideas to which you can refer.

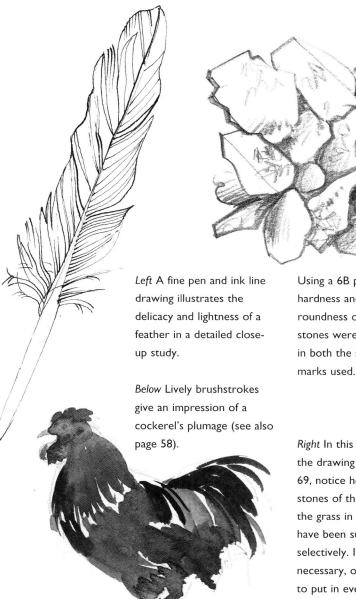

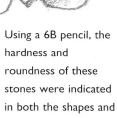

Left A fine pen and ink line drawing illustrates the delicacy and lightness of a feather in a detailed close-up study.

Below Lively brushstrokes give an impression of a cockerel's plumage (see also page 58).

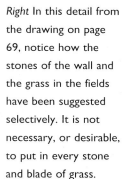

Using a 6B pencil, the hardness and roundness of these stones were indicated in both the shapes and marks used.

Right In this detail from the drawing on page 69, notice how the stones of the wall and the grass in the fields have been suggested selectively. It is not necessary, or desirable, to put in every stone and blade of grass.

Conté pencil was used to draw tree bark with linear markings. A slightly toothed paper contributed to the rough texture.

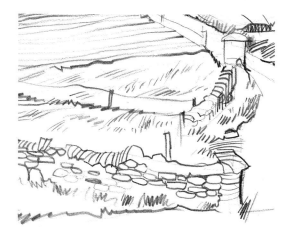

49

PATTERN

Often you will not see the pattern in your subject until you start to draw and become more fully aware of what you are looking at. Pattern is built up from a repetition of elements – of shapes, or markings. These may occur in a real sense (for instance, as the arrangement of the components of a subject, such as the petals of a flower, or stripes on a piece of fabric are real), or accidentally (when your eye detects the patterns made in your subject, by boats moored at sea, or chairs stacked on top of one another, for instance).

Look for the patterns made by natural objects such as pebbles, feathers and seeds, or the centre of a sunflower with its complex spiral patterning of seeds. Look at the fascinating patterns made by reflections on the surface of water.

Consciously make drawings of any patterning you find around you. It is satisfying and reassuring to draw. Use some of the examples shown on these pages; try them with different tools and papers to find out what method best conveys what you are trying to achieve. Use pattern to contribute interest and information to your drawing.

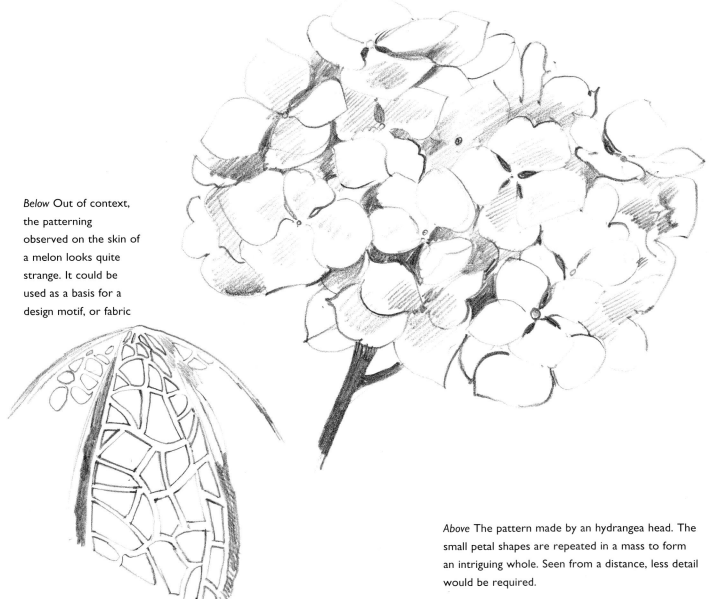

Below Out of context, the patterning observed on the skin of a melon looks quite strange. It could be used as a basis for a design motif, or fabric

Above The pattern made by an hydrangea head. The small petal shapes are repeated in a mass to form an intriguing whole. Seen from a distance, less detail would be required.

Water is elusive and transient, creating patterns that can change in seconds. Capture it quickly, using flowing lines or another shorthand method of putting it on paper. A dip pen with blue ink was used here.

Pattern can be used to impose a structure on the composition of your drawing, which can lead to exciting creativity and invention. You could divide up your surface into a grid, or you could pleat or facet your drawing. Look at the work of the Cubists and Futurists and other modern artists to see how they use pattern in their work.

Cut in half, a red cabbage reveals a fascinating subject. This is drawn with pen and ink and watercolour pencil.

The rounded petals of this ranunculus are arranged spirally and overlap. Drawn with watersoluble pencil.

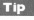

The delicate and spidery pattern of thistledown is drawn using Indian ink and a fine pen line.

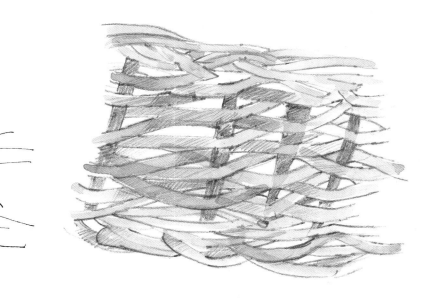

Detail of a basket, drawn with pencil and watercolour — a man-made interwoven pattern.

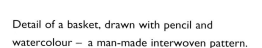

51

CREATING ATMOSPHERE AND MOOD

The character of the marks, textures and patterns you make all contribute to the mood of your drawing. If you wish to convey certain feelings of peacefulness or of tension, the deliberate use of material and method can help enormously.

Feelings of tranquillity, for instance, can be evoked by smooth, continuous lines, often horizontal in direction; using materials that have a softness about them will contribute to the mood. A raging storm, on the other hand, can be effectively conveyed by abrupt, diagonal marks, together with sharp contrast of some other element – tone or colour, perhaps.

Draw on your knowledge and your imagination at the same time. Combine line, tone, texture and pattern to create drawings to show what you feel about the subject.

The drawings on this page show two different moods: mist and quiet, and a stormy scene. Their mood is reflected largely by my choice of different media, and by the nature of the marks made.

Above Pen and ink lines, of a horizontal nature, with a pencil halo around the moon, suggest tranquillity.

Below Bold, staccato lines and dots have an almost explosive quality.

Right Colour adds to the drama of this stormy scene, which was drawn with watersoluble crayons on watercolour paper. Short, stabbing strokes were made, which were then diffused with a brush and a little water. Then more marks were made once it was dry.

Above The effect of mist was created by drawing out of charcoal (see page 44); a base of charcoal was 'drawn into' with a putty rubber to reveal the white of the paper in a hazy way. Charcoal marks and some colour pencil were used for a little detail.

EXPLORING NEW TECHNIQUES

Sometimes it can be difficult to find the right way to express texture and atmosphere, so the wider your range of techniques, the more you will have to choose from. We are very used to conventional tools such as pencils, pens and crayons, and we often forget that there are other, less conventional methods.

At primary school, children experiment freely with all sorts of ideas and often achieve quite startling results. As artists, perhaps we should learn from them; to try things out, and not to be afraid of getting our hands dirty! We need to use our imagination to use everyday and easily available tools to broaden our knowledge of drawing.

Try out the techniques on these pages, then try combining them. And find your own tools and methods of making marks and applying colour.

Right Masking fluid (a latex fluid) can be used to preserve areas of paper in a wash. Use an old brush (it tends to spoil the bristles) or a pen and dip it into the fluid. Draw the parts you wish to preserve. Let it dry before painting over it with a watercolour or ink wash. When the paint is dry, rub the fluid off with your finger (do not leave on the paper overnight). Several layers can be worked by repeating the process with subsequent washes.

Right A white candle can be used to draw with and to create a resist against a watercolour wash. Wax crayons can also be used, if some colour is required.

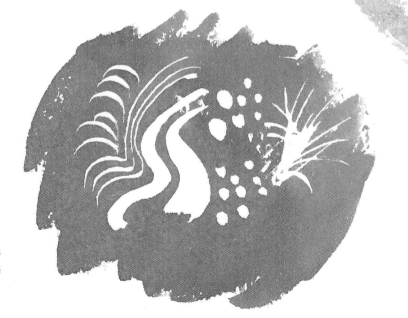

Left Masking tape can be used to mask areas, which are then painted over; useful if you wish to preserve a straight line in a wash drawing. Masking tape can also be cut and used as a stencil. If you have the option, choose the low-tack variety, to avoid lifting the surface of the paper when you remove the tape.

Materials and equipment

You will find the following items useful for the drawing experiments on these pages:

- Toothbrush
- Blotting paper
- Wax crayon or candle
- Masking fluid
- Glue brush
- Straws
- Natural sponge
- Masking tape
- Stipple brush
- Card

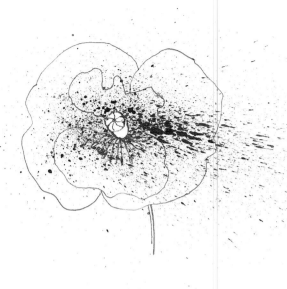

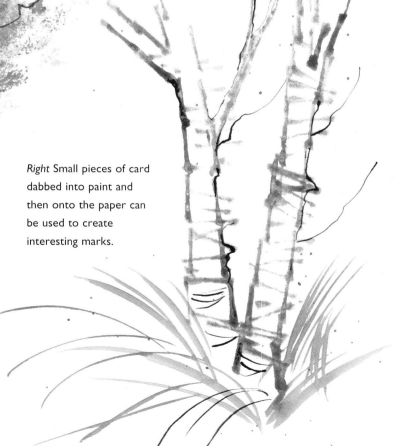

Left A natural sponge (which can be bought from art shops or chemists) can be used to dab watercolour or ink washes onto a drawing. It is useful for creating distant foliage textures. Here, the trunk and branches were drawn first, before the sponge was used with two different green washes.

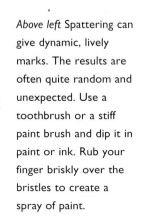

Right Small pieces of card dabbed into paint and then onto the paper can be used to create interesting marks.

Above left Spattering can give dynamic, lively marks. The results are often quite random and unexpected. Use a toothbrush or a stiff paint brush and dip it in paint or ink. Rub your finger briskly over the bristles to create a spray of paint.

Left Here the spattered ink was allowed to dry, and then watercolour and red pastel were used to add colour, with white gouache dabbed on to represent the stamens.

Below Spidery, twig-like effects and strange patterns can be created by blowing through a straw in different directions on blobs of ink or watercolour.

Right Blotting paper can be cut into shapes, dipped into paint or ink and used to stamp repeated elements onto a drawing. Here, a single petal was cut from blotting paper and used in this way, and then further detail was drawn into the flower. Blotting paper or kitchen towel can also be used to blot wet paint, creating texture or lightening tones.

Below Stencils can be cut from card or stiff paper (use oiled stencil paper if you want it to last). Here a leaf shape was cut from card, and the colour was dabbed on with a sponge to give texture; crayon details were added last. A stipple brush (with stubby bristles) is also useful for stencilling, or for applying paint directly.

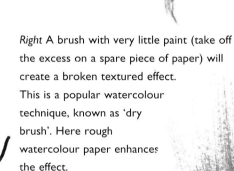

Right A brush with very little paint (take off the excess on a spare piece of paper) will create a broken textured effect. This is a popular watercolour technique, known as 'dry brush'. Here rough watercolour paper enhances the effect.

Pen and Brush Drawing

As you become more familiar with different drawing media, you will begin to find what suits you best, and what suits various subjects best. In this lesson we will take a closer look at methods of drawing with ink, using pens and brushes. These 'wet' media are useful for both line and tonal drawings.

LINE DRAWING WITH PEN AND INK

Using a pen to draw with will make you more decisive – there is no going back on the line you have made as marks cannot be removed with an eraser. Some artists make careful pencil drawings first and then use a pen when they are sure that the basic shape is correct. Drawing directly with a pen, however, is more spontaneous.

Boldly expressive or careful, detailed

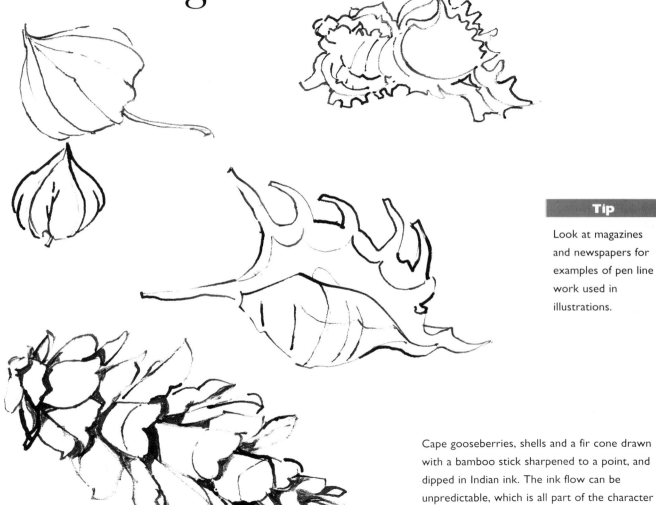

Aims

- To draw with 'wet' media
- To learn to use a brush for drawing
- To make a line and wash drawing
- To use tonal washes

Tip

Look at magazines and newspapers for examples of pen line work used in illustrations.

Cape gooseberries, shells and a fir cone drawn with a bamboo stick sharpened to a point, and dipped in Indian ink. The ink flow can be unpredictable, which is all part of the character of the marks these pens make.

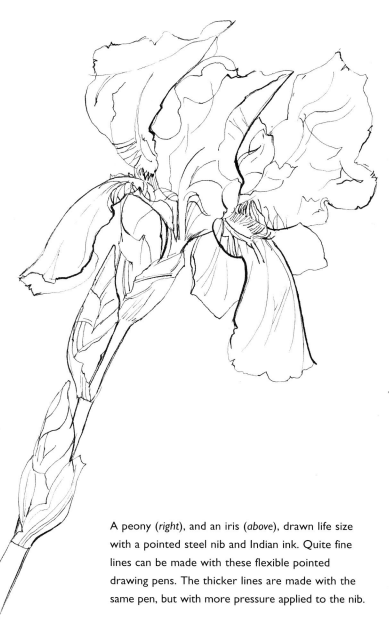

line drawings can be made by dip pens with steel nibs, quills (made from birds' feathers) and reed or bamboo pens. The speed at which you draw, the nature of the line (whether it is sinuous and curved or abrupt and spiky), and the pressure you apply on the nib are all contributory factors. A narrower range of expression is available with fibre-tip pens, fountain pens and ball-point pens, but they can give fluent (if sometimes monotonous) lines, and are convenient to use. It is not easy to draw on a large scale with a pen, so remember to suit your drawing medium to the size of your drawing.

Try different types of ink to find which suits you best. Waterproof Indian ink is recommended for the drawings in this book. Once dry, you can work over your line drawing with washes (see page 60) without the risk of the line blurring or running. If you want to achieve a blurred effect, work with washes before the line dries, or use non-waterproof ink for the line drawing.

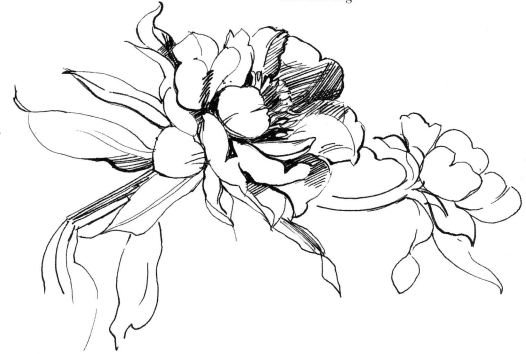

A peony (*right*), and an iris (*above*), drawn life size with a pointed steel nib and Indian ink. Quite fine lines can be made with these flexible pointed drawing pens. The thicker lines are made with the same pen, but with more pressure applied to the nib.

DRAWING WITH A BRUSH

Handling a brush is quite a different experience from using any of the other drawing media, because the hair or bristles give it considerable flexibility.

I recommend that you use a medium-size synthetic watercolour brush with a pointed end (known as a round). Use A3 cartridge paper and Indian ink. Hold the brush in the same way as you hold a pencil, and dip it in the ink, removing any large drips on the rim of the ink bottle. Try drawing long, straight controlled lines, keeping the ink flow steady by applying a constant pressure. Then try some curves, circles and spirals, varying the pressure, noticing the way this affects the line.

Now draw some small natural objects, such as the shells on this page. See how subtly you can express shape and tone by varying the pressure, and therefore the width of the line.

Sepia ink was used for the drawings of the shells on these pages. It is a sympathetic and traditional colour to use. Like all types of ink it can be diluted with water to give different tones.

PAPER

A medium-weight cartridge paper is suitable for line work with ink or paint and pen or brush. If you are working with a large brush or are applying washes, you will need a heavyweight paper, or you will have to stretch the paper to avoid cockling as the ink or paint dries. This will provide a flat, taut surface on which to work.

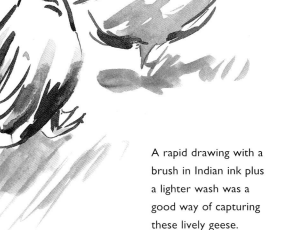

A rapid drawing with a brush in Indian ink plus a lighter wash was a good way of capturing these lively geese.

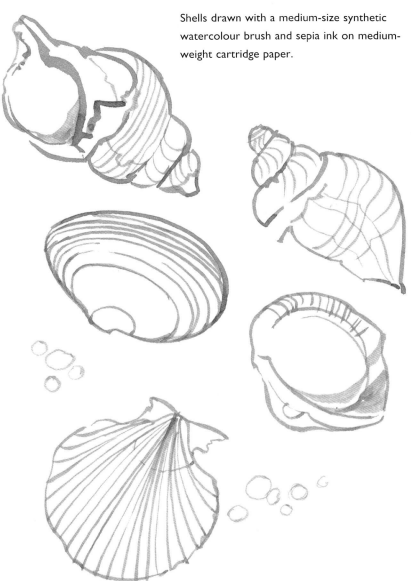

Shells drawn with a medium-size synthetic watercolour brush and sepia ink on medium-weight cartridge paper.

Stretching paper

You will need:
• Paper
• Drawing board (use the smooth side of a piece of hardboard for small drawings, or a piece of thick plywood)
• Gummed brown paper strip, approximately 3.5cm (1½in) wide
• Sponge
• Clean bath or large sink containing water.

Method

Submerge the paper in the bath for a few minutes. Remove carefully and allow the excess water to drain off. Place it flat on the board, smooth out with your hand or a sponge, and wipe off any excess water. Tear off four strips of tape, slightly longer than the edges of the paper. Dampen one strip with a sponge and tape down one edge, then the opposite edge, then the two remaining edges. Allow the paper to dry flat at room temperature (do not try to speed up the process with heat)

Make your drawing with the paper still attached to the board, and, when you have finished, cut away around the edges with a craft knife.

Tip

Always wash your brush thoroughly when you have finished working, particularly after using Indian ink.

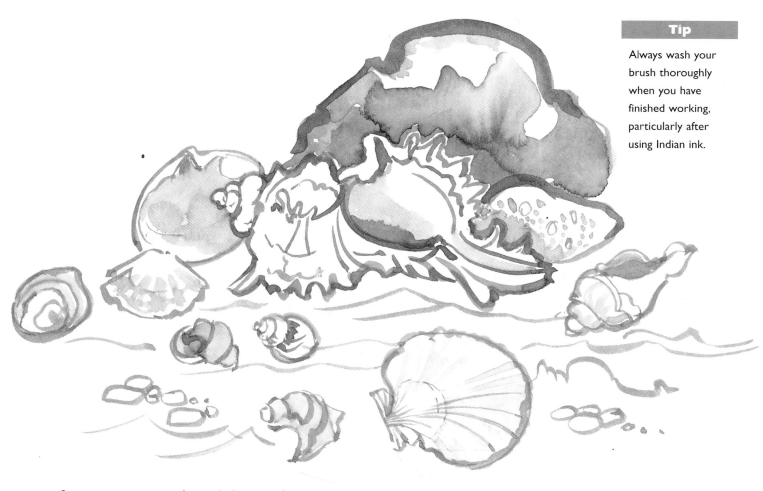

Set up an arrangement of natural objects, such as these shells. Take time to observe your subject before endeavouring to capture its essence with the brush. Dilute the ink to make different tones, keep the brush moving and don't worry about mistakes.

LINE AND WASH

A wash is a dilution of ink or watercolour added to a drawing to enhance its meaning. Washes may be tonal, coloured, gradated and blended, but they should always be part of the drawing. The line drawing can be made first, and the washes added to it, or the washes can be put in first and then drawn onto. You have to suit the method to the situation, to the time available, and perhaps to your own temperament.

A tonal range of monochrome washes can be made by diluting with water, mixed on a palette or saucer. It is useful to make a tonal scale with the washes you are using so that you can keep tonal contrast clear and controlled. Washes can be blended on the paper by applying darker or more dilute mixes to wet areas on the paper. Alternatively, a wash can be allowed to dry before applying the next layer to increase the tone in certain areas, leaving a well-defined division between the different tones (see page 62).

A wash can be applied to a drawing done in any media. An interesting way of exploring this is to choose a subject (such as the freesias on this page) and to make several studies using a variety of media. You may also wish to try different papers, including tinted papers.

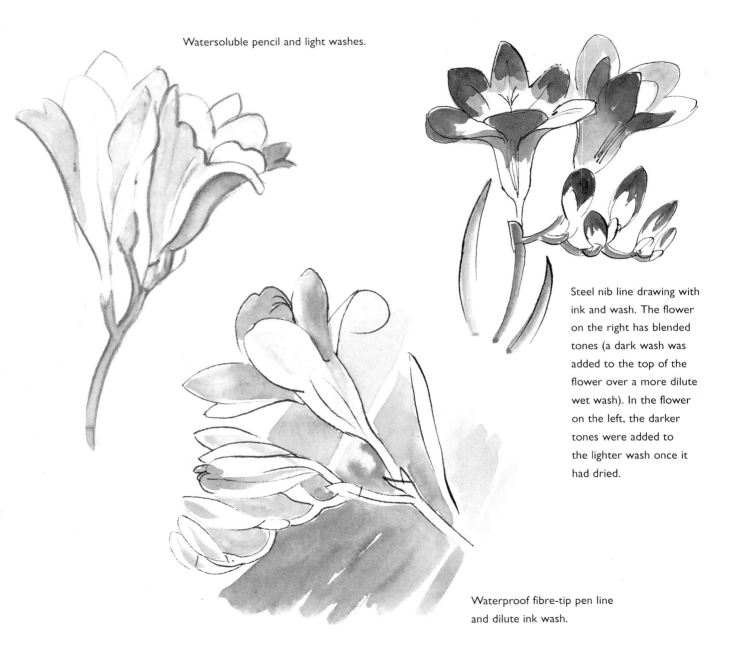

Watersoluble pencil and light washes.

Steel nib line drawing with ink and wash. The flower on the right has blended tones (a dark wash was added to the top of the flower over a more dilute wet wash). In the flower on the left, the darker tones were added to the lighter wash once it had dried.

Waterproof fibre-tip pen line and dilute ink wash.

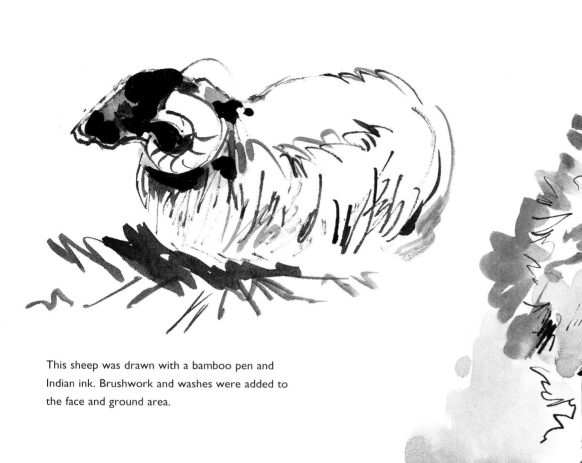

Working rapidly, washes were added to this line drawing of a building. In some areas this was done before the ink had dried, causing the lines to become blurred.

This sheep was drawn with a bamboo pen and Indian ink. Brushwork and washes were added to the face and ground area.

Making a bamboo pen

Make your own pen with a dry bamboo garden cane, or a piece of freshly cut green bamboo. With a craft knife make a diagonal cut to take off the end. Then shave both sides of the cut-off end to make a nib of whatever width you require.

LINE AND WASH STUDY

When you feel confident about using line and wash, try a more complex subject, such as a still life. This study will involve a considerable amount of water on the paper, so you will need to stretch the paper if you are using a medium-weight cartridge paper (see page 57). Use a brush (medium-size watercolour brush), a dip pen with a pointed steel nib and waterproof Indian ink.

Set up your subject as you have done in previous exercises, find the best viewpoint, and make a couple of thumbnail drawings, including a tonal study in ink. Make a tonal scale to establish the darkest and lightest tones, and some mid-tones.

Draw the still life in pencil on the stretched paper: start by plotting the overall shape, drawing a central construction line (see page 26), and roughing out the shapes.

Look carefully at your subject and decide which are your lightest grey tones and paint these in. Then establish where your darkest tones are and work towards them, building up the tones gradually from light to dark across the whole drawing, relating tones and shapes. Increase the depth of tone carefully until you feel it represents the tones that you can see in your still life.

STEP 1

Make a very dilute mix of Indian ink on your palette, and with the brush, paint in the lightest grey area. Allow to dry.

STEP 2

Mix the next darkest tone and apply with the brush.

STEP 3

When dry, place the darkest tone.

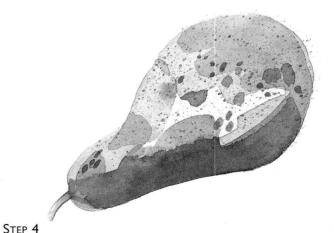

STEP 4

Any surface texture can be applied at the final stage, once tonal values have been established. The mottled appearance of this pear has been spattered with ink from the brush (see page 54).

Tip

Use a heavyweight
hot-pressed paper if
you want to avoid
having to stretch
your paper.

The darkest tone is on
the bottle, the lightest
tones on the apple and
pear and rim of the
pot. The remaining
tones are shades of
grey, which needed to
be closely observed. I
used an ink line to
finish the drawing and
some spattering on the
pear and pot.

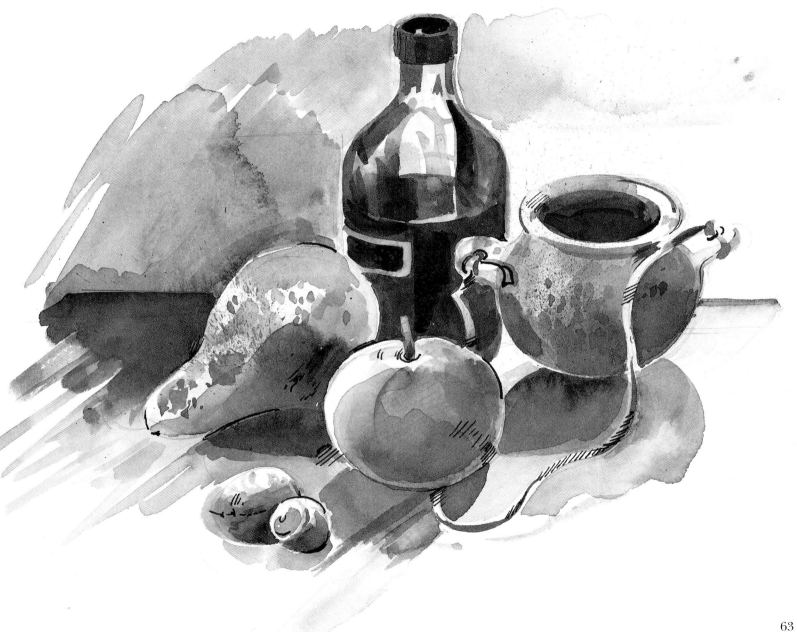

Composition

Today, it seems that there are no rules regarding composition. Nevertheless, most artists tend to develop an idea or theme which runs through their work, and this will come to you in time.

Making a composition brings in all the factors you have been exploring: line, tone, colour, shape and texture. It is only by looking and drawing that you will be able to decide if your composition looks right, and whether it is harmonious.

Whatever your subject (particularly if it has more than one element in it), a dominant theme will emerge. It could be rhythm, symmetry, or movement; it could be based on a rigid grid, or have a device which draws the eye to a centre of interest. Often the subject itself will suggest a composition to you and sometimes you must impose a structure on the arrangement.

Aims

- To understand some basic ideas about placement and composition
- To arrange and draw a still-life composition
- To draw a landscape composition

When you are composing a picture you may intuitively know when it looks right. To train your eye it is helpful to study the work of other artists and make thumbnail sketches to reveal the dominant elements of a composition. The sketches below show some devices that are commonly used, such as diagonals, focal points or an underlying triangular structure. It is generally true that a composition should have cohesion with

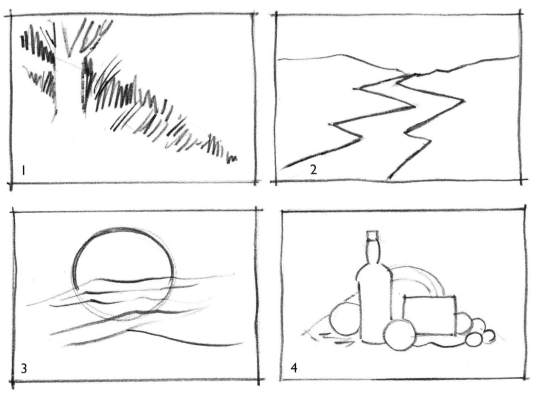

Tip

Experiment with abstract shapes before making final decisions about a composition.

1 Diagonal compositions are often pleasing. A vertical element can help to stabilise the diagonal movement.

2 Lead the eye into the picture area of a landscape by using a device such as a road or stream, or the contour lines of a field.

3 A dominant or well-placed feature will create a focal point and centre of interest.

4 A triangular composition owes much to Renaissance artists.

elements relating to one other without wandering off the picture area.

Composition is mainly about choice. Two of the first choices you must make are about the subject itself and the view you have of it. A viewfinder will help you to select a view and to focus on it.

MAKING A VIEWFINDER

A viewfinder is basically any device that allows you to frame up your subject and to look at it through a small window. Use an empty colour slide holder, or a postcard with a rectangle cut in the middle of it. Keep your view constant by holding the viewfinder at the same distance from you.

Viewfinder

Right These thumbnail sketches show two arrangements with a diagonal element. Be flexible in your approach and don't be afraid of changing items in a group.

ARRANGING A STILL-LIFE COMPOSITION

A still-life subject allows you to construct your own composition. Take a few objects and arrange them in different ways until you have achieved a pleasing balance. Use your viewfinder to look at the group from all angles to find the best arrangement. Consider whether the format should be portrait (vertical) or landscape (horizontal, as shown below), and make small 'thumbnail' sketches in order to help you make your decision.

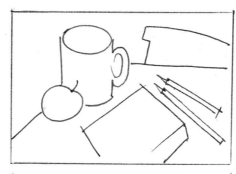

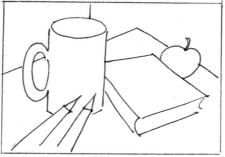

Enlarging Being able to enlarge an image correctly is useful if you are working from small studies or sketches, rather than from life. Before enlarging, make sure that the proportion of the paper is correct by running a diagonal through the original image as shown (*below left*). Draw a grid over the small image, then a corresponding grid on a large scale on the large sheet of paper. Now transfer the image, box by box, and everything will be in proportion. Accuracy will be increased by making a grid with small squares.

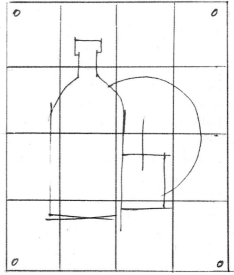

Transferring Use one of these methods to transfer a drawing: Place a sheet of paper over your drawing and place both on a light-box or against a window to let the light reveal the drawing. Trace the image through. If the top paper is too thick, the image can be transferred using a tracing-down paper (made by rubbing red chalk over a sheet of thin paper – it will act like carbon paper but leave a weaker line). Sandwich the tracing-down paper between your image and the paper you wish to transfer it to, and draw over the lines of the image. The red chalk will transfer the lines.

STILL-LIFE COMPOSITION

Now set up a group of objects and develop it into a fully worked tonal still-life composition. I arranged a group of familiar objects on a white cloth with a plain background on the table in front of my drawing board.

Start by looking at the still-life arrangement from various positions, and use your viewfinder to focus on the subject and cut out extraneous detail. Make thumbnail sketches of close-up and more distant views. Ask yourself whether there is a centre of interest. Make changes if necessary to the composition or your viewpoint. Decide what is important to you in the drawing of the subject. Draw the arrangement you prefer and then develop it into a tonal drawing, working out the relationship of light and dark areas.

Top A portrait format with the objects seen close up (*left*), and from a distance (*right*); both these views are too extreme, and as a result the composition is not balanced.

Bottom A portrait format (*left*); the objects are too bunched together. A satisfactory composition (*right*) in a triangular arrangement, with a comfortable amount of space around the group. This sketch and the scale (*far right*) establish the tonal range.

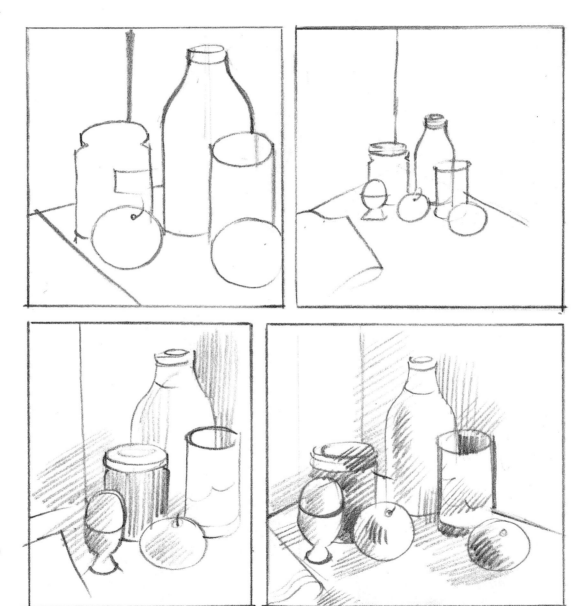

For the drawing you will need A3 cartridge paper, 2B and 3B pencils. Don't forget to keep a good point on your pencil.

The starting stages are important. Plot out the composition in the same proportions as your sketch (see page 65), and decide on a central point, making sure you will be able to leave a margin around the edge of your paper.

Start by drawing the tallest object and connect the other shapes to it, noting the spaces between them and how much each part overlaps the next. Draw lightly so that you can make corrections.

Walk away from your drawing, and when you return to it go over important points, checking distance and proportion. Start to use tone, noting the very darkest and the lightest areas, then put in the mid-tones. Check the direction of light and relate each object to the next, checking its tonal relationship. Use the tone to help to describe the form of the object. Reflections and shadows may confuse you, so use your tonal scale if it helps, and try to record them as accurately as you can.

Finally, consider texture: the roughness of the fruit, and the shine of the glass, for instance. (Notice that the rim of the glass is only suggested where it catches the light, and is described by the tones around it.)

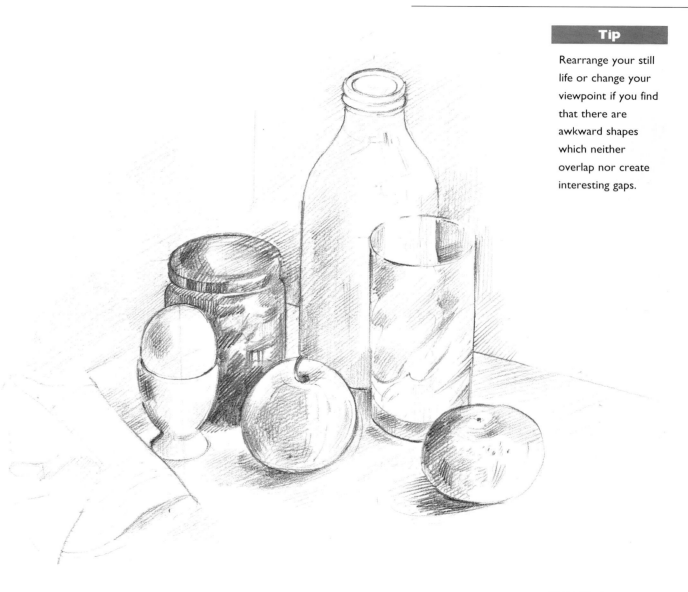

Tip

Rearrange your still life or change your viewpoint if you find that there are awkward shapes which neither overlap nor create interesting gaps.

BREAKFAST STILL LIFE

COMPOSING A LANDSCAPE

Landscape is a word that conjures up pastoral scenes, but it can encompass almost anything of an outside nature: seascapes, townscapes and cityscapes. From an Italian hilltop to a Cotswold farmyard, or a view down the garden, landscapes present an exciting challenge to the artist.

Landscape is often a complex subject which can involve depicting a large area. Beginners to drawing may find it difficult to portray distance, but if you remember two useful points, you will not go far wrong. Firstly, that all objects get smaller as they recede. Secondly, that objects in the distance are generally less distinct than objects in the foreground.

When tackling a landscape, simplicity is important – it is so easy to try to take in too much. Be clear about your intentions, and if you find your interest wandering, remind yourself what it was that caught your eye originally about the scene, and return to that thought.

It is useful to bear in mind some aspects that are illustrated on this page. Remember that a strong horizontal element, if centrally placed, could cut your composition in half. A focal point of interest, or a contrast between different areas, may help your composition, and don't forget that the sky

Strong horizontal divisions should be carefully placed.

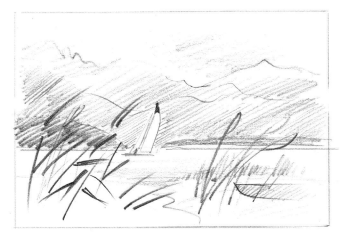

Identify the centre of interest in your composition.

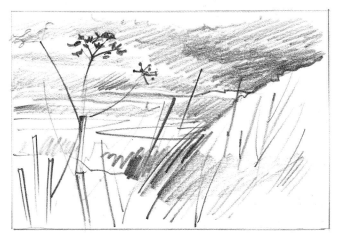

Foreground interest contrasts with less distinct distant areas that contain no detail.

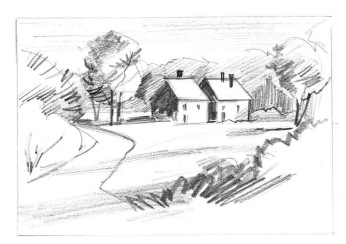

Note the direction of the light and keep shadows consistent.

can add interest and drama. Light is an important factor – in the afternoon it will be quite different from the morning and could affect your composition.

If you find the idea of a composition too difficult, just start drawing and allow your drawing to grow. This is useful when drawing street scenes, when it can be hard to know where to stop. And, if you are finding your chosen spot too difficult, move and try again. Don't always think of drawing a 'picture' – sketching different views is, like taking notes, always useful later (see page 114).

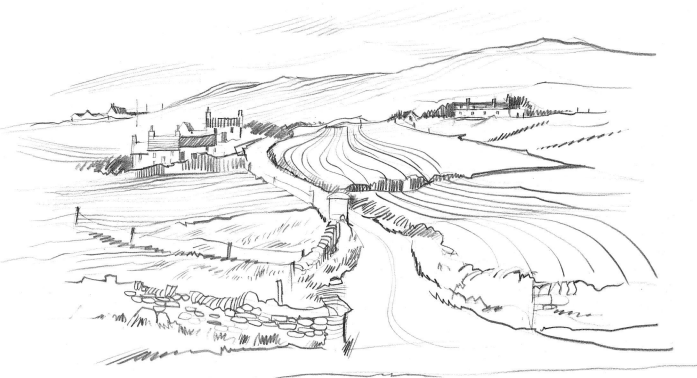

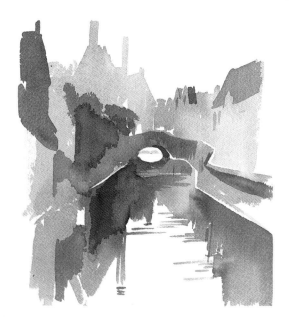

BRUGES CANAL

There is a type of symmetry about this composition. Colour is implied by the use of tonal washes which evoke a quality of stillness.

WELSH LANDSCAPE

This composition takes in a very wide view. The road and the furrows of the ploughed fields lead the eye on a diagonal far into the distance, where the lines are echoed in a less well-defined way. The vigorous linear quality of this drawing gives it a strong sense of movement and texture.

FARM COTTAGES

The cottages are the centre of interest in this composition. Placed slightly off-centre, the eye is led to them along the diagonal of the path. There is another strong diagonal in the line of the hill, which is broken by the vertical element of the tree to the right of centre. Textures and mood are evoked by the use of charcoal tones using the method described on page 44.

Tip

Take care not to cut the composition of your drawing into two halves, either vertically or horizontally, by introducing an element that is too obvious and strong.

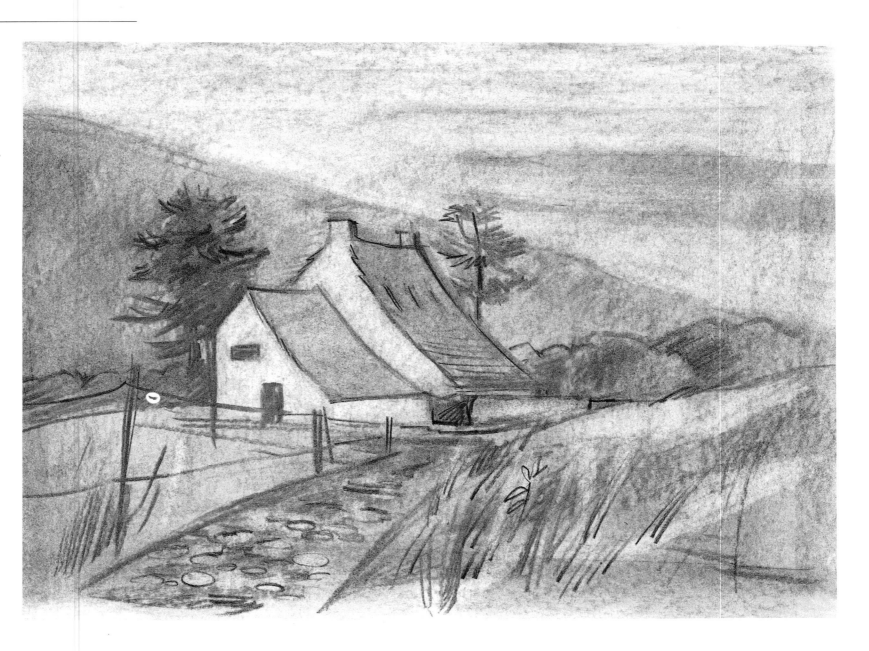

70

A DOORWAY IN DORSET

Sometimes when you are working in the landscape, a scene can catch the eye and becomes an irresistible subject for a close-up study. Here, the view is closed off by the wall and the darkness of the open doorway. With little concern for spatial considerations, colour and texture became the striking feature of this composition. Mixed media techniques (see page 21) were used to dramatic effect.

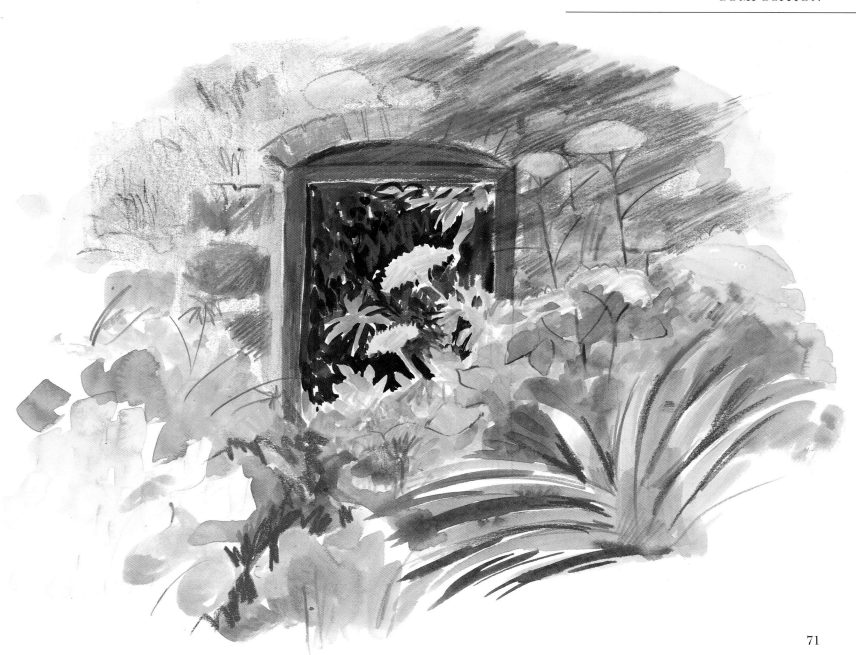

DRAWING A LANDSCAPE

Find a view that you like, in the country, town, or in a garden, and, before starting, spend a few minutes looking at it. A viewfinder is very useful for focussing on composition in landscape drawing. Once you have chosen a view, stay in the same position. You will be surprised how much a few steps away in any direction will alter your view, and therefore the composition. Make yourself comfortable either sitting or standing.

Start by identifying your eye level (an imaginary horizontal line on a level with your eyes, see page 85). Quietly study your subject, make thumbnail sketches and, working small to start with, take careful measurements. Establish the foreground, middle ground and distance, and decide on your centre of interest; note the direction of the light (and remember to take account of the change in the direction of light as the day progresses and the sun moves).

Draw what you see in front of you; if it looks wrong or odd, check your measurements, then get up and move away from your work – you will spot mistakes more easily when you return.

STEP 1

Once you have selected your subject establish your eye level, and place the main shapes and areas simply on the paper.

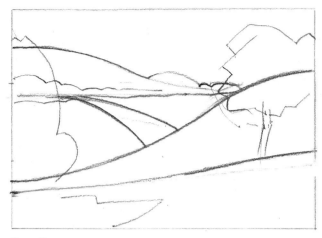

STEP 2

Add the most important features, concentrating on the dominant elements – here, a strong diagonal movement.

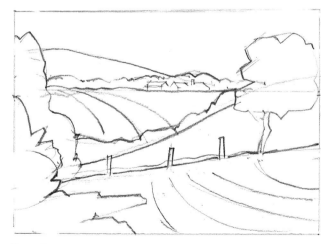

STEP 3

Continue to add other features, checking across the drawing to see that all the elements are correctly related.

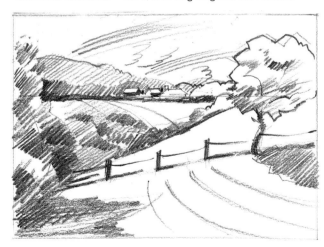

STEP 4

Add final details and place tones. Be clear about your darkest and lightest tones, making mid-tones harmonise.

DORSET LANDSCAPE
This coloured drawing of the landscape was drawn at a later time in my studio, using the pencil drawing and some written colour notes as reference. I used pastel pencils on grey Ingres paper, which acts as a mid-tone for the drawing.

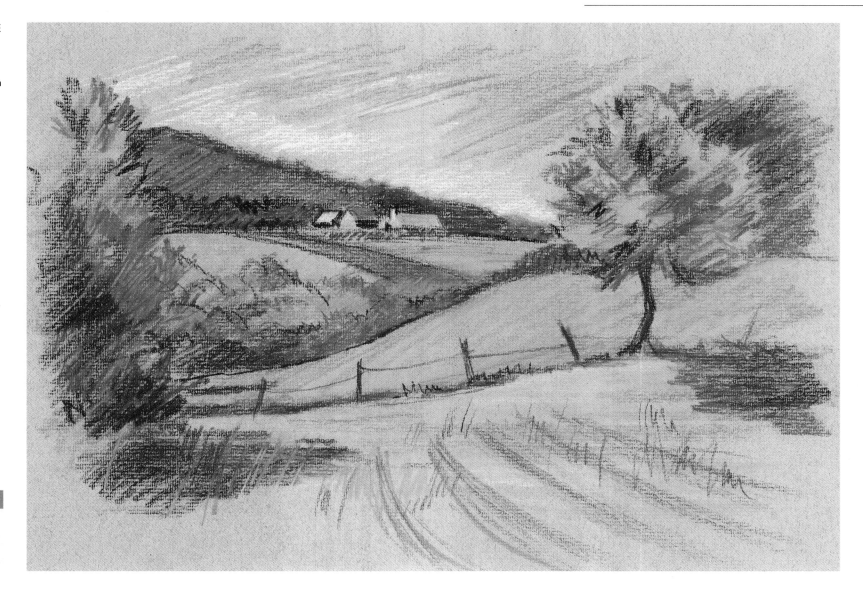

Tip

Three minutes' observation is time well spent.

Colour

Colour can be used to make a drawing more meaningful and interesting, and also to give more information about the subject. Colour can be introduced into drawing in many subtle ways: by the use of a single colour, such as sepia, or by working with coloured or tinted paper, for instance. When colour becomes more dominant in a drawing our understanding of its effect becomes more important.

Colour in drawing is descriptive – it can tell us, for instance, that one apple is red and another green. Colour can also indicate mood; we can immediately register happy colours and sad colours.

For painters, colour studies of a subject are usually an important part of preparing for a composition of a subject.

Aims

- To add to the experience of drawing
- To introduce basic colour theory
- To understand the relationship between tone and colour
- To discover techniques for colour mixing with coloured pencil, watercolour and pastel

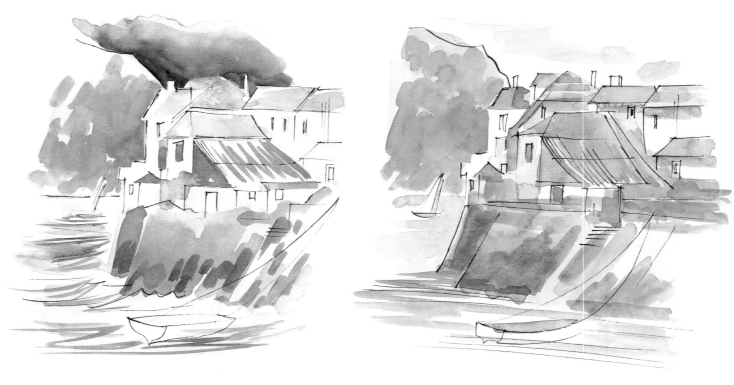

SOME FACTS ABOUT COLOUR

It is useful to know about some of the terms that are used in connection with colour, and about basic colour theory. The theory does not have to be put into practice, but it can be a useful device to give impact to your drawing, and often we use it without being aware of it.

The colours of the spectrum are generally arranged on a colour wheel (see opposite). The primary colours are red, yellow and blue. Pairs of primaries mixed together produce secondary colours (red + yellow = orange, yellow + blue = green, blue + red = purple).

Complementary colours are those opposite each other on the colour wheel (red and green, blue and orange, purple and yellow). They are often found together in nature and work well together in a drawing or painting.

Colour affects the mood of the subject. Here muted neutral colouring (*above left*) evokes a sombre mood, while brighter primary colours (*above*) are cheerful, as well as being more descriptive.

Neutral colours are made when all three primary colours are mixed; earth colours are a range of mainly brown colours (such as ochres and umbers).

Local colour is the term given to the actual colour of the subject unaffected by light or shade.

As you work with colour, you will become aware of its properties and diversity. For instance, colour has a temperature: blues, greens and purples are said to be generally cold colours, while reds, yellows and oranges are hot. However, some blues are warmer than others, and reds can vary from those with blue undertones to those with brown undertones. For this reason the

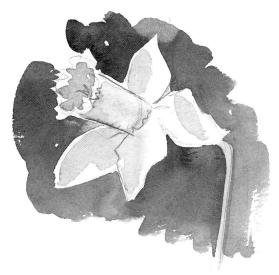

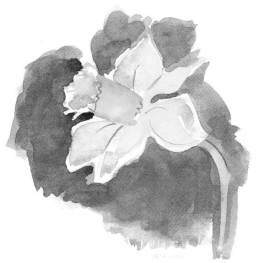

Far left Grey tonal washes are used to imply colour. Green is represented by darker tones, and yellow by lighter tones.
Left Colour indicates light and shade.

choice of compatible colours for your colour wheel is quite critical. It is also interesting to notice that warm colours tend to advance towards the eye, and cold colours to recede.

COLOUR AND TONE
Colour has tonal value (some colours are lighter than others). This can be understood more clearly if you half-close your eyes when looking at a subject (or if you make a black and white copy of a colour picture). The tone and actual colour of an object can be greatly affected by light and shade. On a sunny day observe how bright light can change dark colours, and how, in shadow, a light object can look quite dark.

If you have difficulty controlling the tonal values of colours in a drawing, use a line to define the edges of areas. This will help to make the tonal differences less important and obvious.

Below An interesting exercise is to try to match tone to colour by making some corresponding tonal and colour scales.

COLOUR WHEEL
Make a colour wheel using three coloured pencils (red, yellow and blue), blending them to make orange, green and purple as shown.

COLOURED PENCILS

When using coloured pencils, colours are mixed on the paper using hatched or blended strokes, working from light to dark or dark to light. To get the best from the pencils it helps to keep the point sharp. By applying pressure on the pencil you will increase the intensity of the colour, but this can also be achieved by using a light, medium and dark tone of each colour. White paper shows the colours at their purest, but try coloured papers to see how colours are affected. Working on a smooth paper will allow for highly detailed work, but more textured papers will give interesting results too.

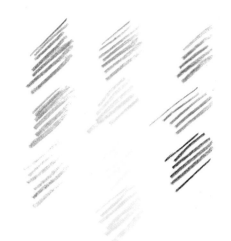

Right This geranium was drawn in coloured pencils on hot-pressed paper, using the colours shown above with hatched marks. Colour is brought into the background, while darker accents in the flowers draw attention to this area.

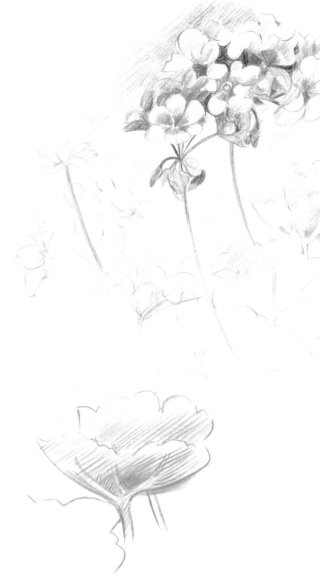

The leaf is drawn with dark green to establish shape, colour and dark tones, using diagonal hatched strokes.

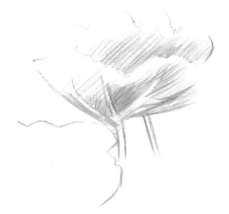

Yellow diagonal strokes in the same direction modify the colour.

Further strokes with a lighter yellow are hatched over the area, and also the background.

Whichever colour medium you are using, start by observing your subject well and selecting a 'palette' of appropriate colours. Think in terms of choosing primary and secondary colours plus black and white. Other useful colours (particularly for drawing buildings) are earth colours, such as yellow ochre, burnt sienna and burnt umber. Mixed with greens, these are also useful for landscapes.

WATERSOLUBLE COLOURED PENCILS

These pencils are used in the same way as ordinary coloured pencils, but colours can be dissolved and blended by the addition of water with a brush to create the appearance of a watercolour wash. Further marks can be made on top of washes once they have dried. Alternatively, try working onto damp paper.

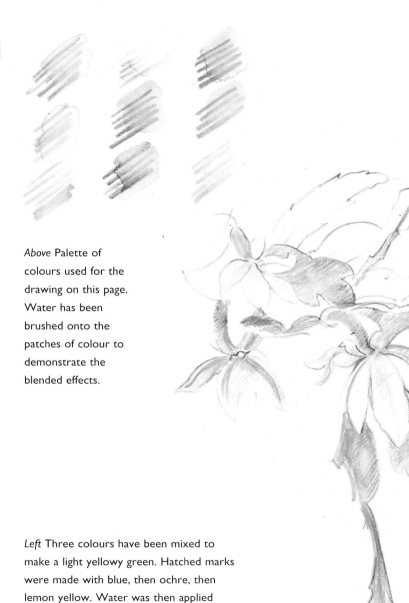

Above Palette of colours used for the drawing on this page. Water has been brushed onto the patches of colour to demonstrate the blended effects.

Left Three colours have been mixed to make a light yellowy green. Hatched marks were made with blue, then ochre, then lemon yellow. Water was then applied with a brush to diffuse the colours slightly.

Watercolour pencils were used to draw this flowering cactus in a very delicately blended way. The water applied with a paint brush has dissolved most of the marks.

Tip

Don't forget to use a heavyweight paper when you are using this medium with water, to prevent the paper cockling.

USING WATERCOLOUR

Watercolour can be used in brush drawing (see page 58) for a linear effect, or it can be laid in washes with line drawings to give them more meaning. Its effects can be both delicate or bold, and it gives great scope for colour in your drawing.

When using watercolour, try to keep your colour mixes as simple as possible. Remember to wash your brush frequently, keep the colours fresh and replace the water in your water jar often.

Set out your pans of colour, or squeeze a little colour from the tube onto your palette. Wet your brush and transfer some colour to your mixing palette or saucer. Wash your brush before transferring a different colour. Mix well and add as much water as you need to the colour mixture. The slightest change in proportions of colour mixes, and the amount of dilution with water, will enable you to achieve a surprisingly wide range of colours. Try out your colour mix on a spare piece of paper before applying to your drawing until you are confident of colour mixing.

Start with the three primary colours. These will enable you to obtain a good range of colour mixes and to achieve useful browny greys. With practice, you will find ways to use the paint which will suit you

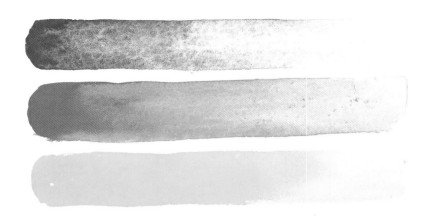

Ultramarine, cadmium red and cadmium yellow have been used here. The colours graduate from a full-strength mix to a diluted pale tint, achieved by the addition of water to the brush as the strokes are drawn across the paper.

Left Experiment with different ways of mixing your watercolour washes, using quite strong mixes of colour while you practise.

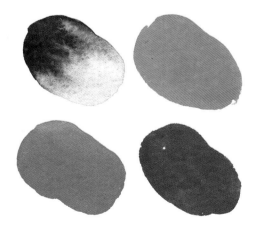

The three primary colours are mixed on the paper, allowing one to bleed into the other (this is a watercolour technique known as wet-into-wet).

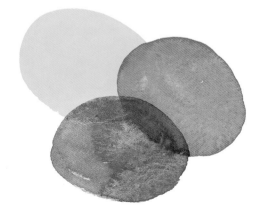

Pairs of the three primary colours are mixed with water on the palette. The colour bottom right is a mix of all three colours, producing a neutral.

Overlapping washes of the colours will mix on the paper. Each layer was allowed to dry before applying the next: first the yellow, then red, then blue.

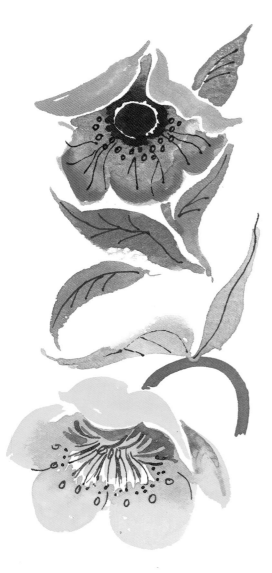

and enable you to produce the results that you are seeking. Try not to be too rigid in your approach. The study of various artists and their methods will give you ideas. Rembrandt, Constable and Turner all used watercolour to give more meaning and atmosphere to their drawings.

Left The colours and different methods of mixing used on the opposite page were used for these flowers. The white of the paper is used as a colour in the drawing. Details were added with a fine pen and ink line once the colour washes had dried.

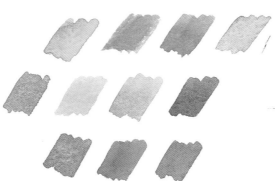

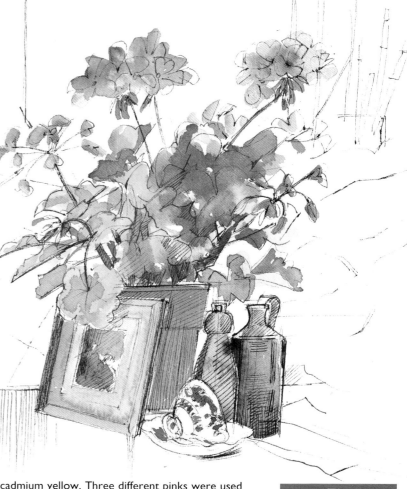

Above A range of delicate watercolour washes was used to give colour to the pen and ink drawing (*right*). Notice how the colour in the foliage and flowers is quite loosely applied, giving the drawing life and spontaneity. The greens of the foliage were mixed on the palette from ultramarine blue and cadmium yellow. Three different pinks were used for the flowers: rose madder, magenta and carmine. The other objects are painted with unmixed colours: yellow ochre, brown madder, burnt sienna and blue-black.

Tip

Change your water frequently, and keep your palette and brush clean.

PASTELS

When drawing, some students find it only too easy to become rather rigid in their approach, drawing too small, too detailed and too tight. Using a broader medium, such as soft pastels, on larger sheets of paper, will loosen you up and give you greater freedom of expression. Pastels are an excellent spontaneous drawing medium, in which drawing and colour are combined together.

Use pastel paper, or sugar paper. Pastels need a paper with a 'tooth' that they can adhere to. They are best used with the work held upright at an easel, to allow the pastel dust to fall, keeping colours bright.

Pastel colours can be built up in layers; they can be gradated and smudged to blend colours, or marks such as dots, strokes and dashes of different colours can be used side by side so that colour appears to mix owing to their proximity. The intensity of colour can be increased by applying more pressure to the pastel stick. The colours are opaque and so they can be worked from dark to light, as well as from light to dark.

Right Drawings of leaves and flowers show how pastel colours can be mixed, using blended, hatched and stippled marks.

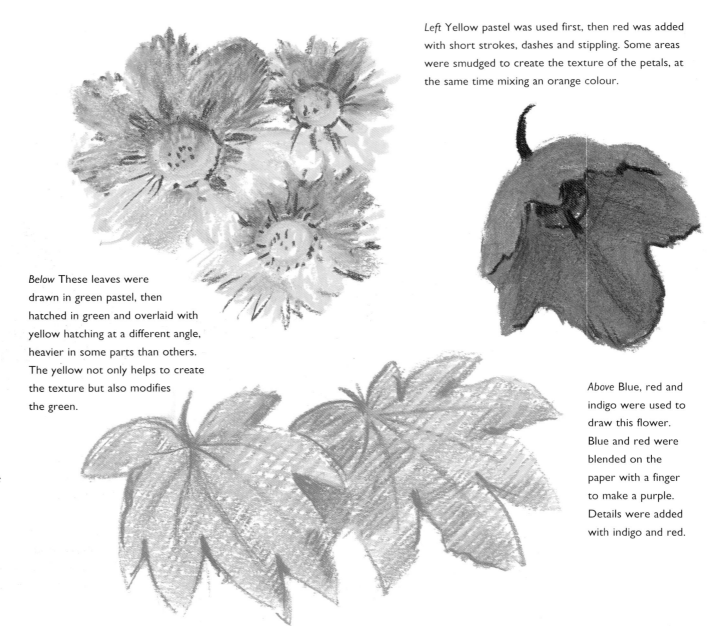

Left Yellow pastel was used first, then red was added with short strokes, dashes and stippling. Some areas were smudged to create the texture of the petals, at the same time mixing an orange colour.

Below These leaves were drawn in green pastel, then hatched in green and overlaid with yellow hatching at a different angle, heavier in some parts than others. The yellow not only helps to create the texture but also modifies the green.

Above Blue, red and indigo were used to draw this flower. Blue and red were blended on the paper with a finger to make a purple. Details were added with indigo and red.

This simple landscape used six colours (shown below). The green-grey Ingres pastel paper adds a further colour where it shows through in the sky and water. The sombre colouring conveys the menacing effect that mountains can have.

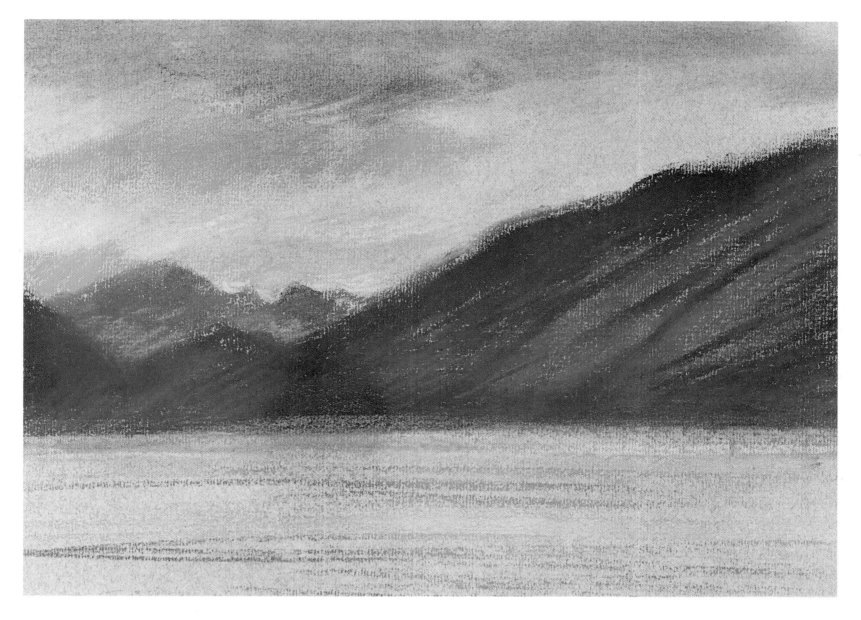

WORKING WITH COLOUR

We have discussed using various colour media, and no doubt there is one that you feel particularly suits you. However, it is not the medium or the method which is important so much as how you, as an artist, see the subject.

To make a proper exploration of colour and your response to it, I suggest that you take a subject – it might be trees, buildings or flowers, for instance – and go out with your sketchbook to make your own colour studies and notes from life. Use whichever medium you prefer and concentrate on the effect of colour and what appeals to you.

Notice, for instance, the subtle variety of greens that occur in nature, the way complementary colours – red and green, blue and orange, yellow and purple – actually do complement one another, the way the colour of the sky can change in moments, the way certain colours – such as purple and yellow – seem to have something rather mysterious about them. Respond to colour on an emotional level – is it strident or calm, or is it quite neutral? Consider how these things will affect the quality of your drawing.

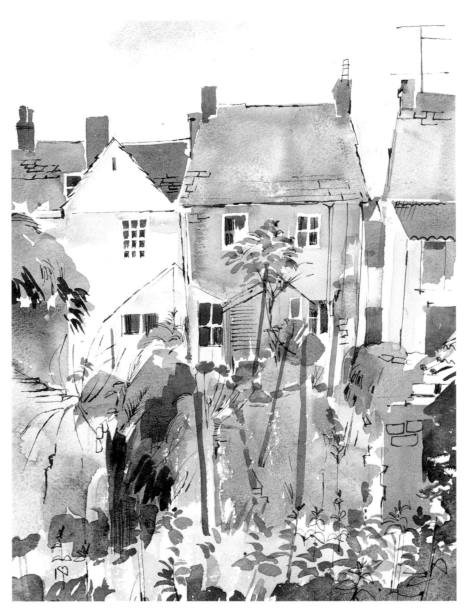

TOWN GARDENS

A subtle range of earth colours and greens has been used, giving a peaceful mood to the drawing.

Line and watercolour wash is a medium that seems to lend itself to drawings of buildings. The washes were applied loosely with a large brush. When dry, pen and Indian ink were used to give definition to the houses and plants.

Tip

A small box of pastels is easily carried in a coat pocket, making it a useful medium for sketching, as well as for more developed drawings.

HYDRANGEAS AND CIDER JAR

The dominant colours in this drawing are complementaries — pink and green — a colour combination that occurs frequently in nature. The earth colour of the cider jar offers a contrast.

This still life required a sound knowledge of the handling of pastels. With practice, and confidence in your drawing skills, you will be able to tackle a subject such as this.

The image was drawn lightly first with charcoal to establish the composition and the general tones. Broad areas of colour were applied and tonal values were checked before any details were added.

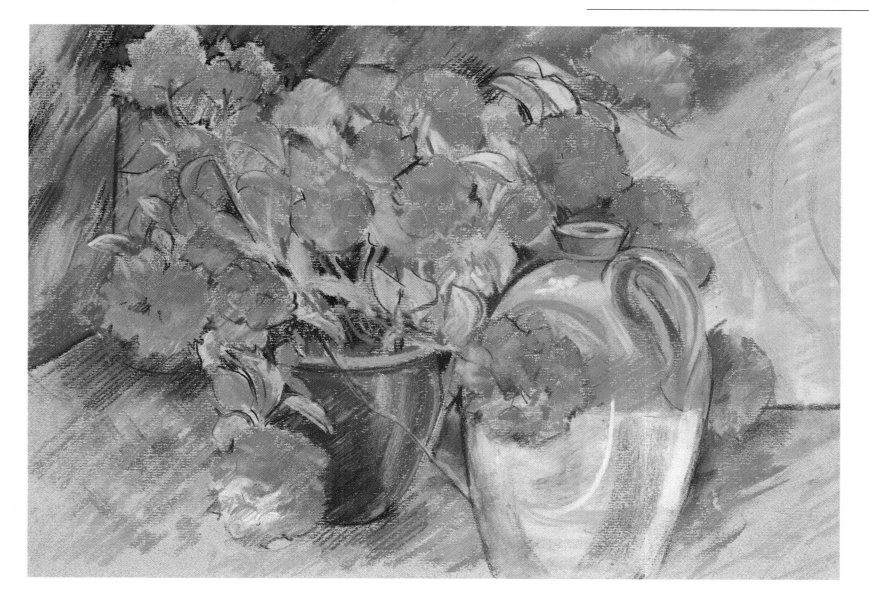

Perspective and Buildings

Perspective provides a method of creating space and distance on a two-dimensional surface. There are some clues and techniques that can help you to achieve this. It creeps into drawing no matter how much we wish it would go away! But rather than using it as a starting point for your drawing, I suggest that you begin with close observation and accurate measuring. Only when something in your drawing looks odd should you check the perspective.

SCALE AND DISTANCE

It is important to be able to create the illusion of space. We realise that objects in the distance appear smaller than the same objects closer to us, even when we know

that they are actually the same size. To convey this successfully, an idea of scale must be established, and all objects at a certain distance must relate to each other in terms of size. Doors, for instance, must be large enough for figures to pass through. Clouds, which are large overhead (where they are nearest to you), become smaller as they move away into the distance.

MEASUREMENTS AND ANGLES

To achieve an accurate sense of scale (particularly when drawing buildings and street scenes) it is important to remember to check measurements, angles, spaces and shapes, and to be aware of negative spaces (see Lesson Two). Make sure that vertical lines really are vertical in your drawing. Use a plumb line (see page 24), and use the edge of your board as a vertical guide.

AERIAL PERSPECTIVE

The clarity with which we can see something is reduced by the atmosphere over large distances, and so distant objects tend to be less distinct than objects in the

These windsurfers are the same size, but the furthest one appears to be smaller than the one in the foreground, giving a sense of scale to the scene.

The sides of the road converge towards each other as they recede away into the distance.

Aims

■ To look at some basic rules of perspective
■ To learn how to draw buildings in perspective
■ To consider aerial perspective
■ To use your knowledge of perspective to help you to draw buildings

foreground. This can be used as a device to exaggerate the sense of space in a drawing.

EYE LEVEL

You will have noticed already that the slightest change in your position when drawing will alter your view of the subject. To prevent this happening, you need to establish your eye level, which is an imaginary horizontal line at the same level as your eyes. Note where your eye level cuts across the scene in front of you, whether you are sitting, standing or lying down.

If you look carefully, you will see that receding lines above your eye level will appear to recede down towards it, and lines below your eye level appear to recede up towards it. This is most apparent if you stand on a straight road which disappears into the distance. The point at which the parallel sides of roads meet on your eye level is called the vanishing point.

Accurate verticals are important in this composition, giving a framework on which to relate other shapes and angles. Notice the converging lines on the floor, which recede up towards the eye level, the tonal recession of the door and window frames, and the contrast between the clearly defined foreground and the less distinct background.

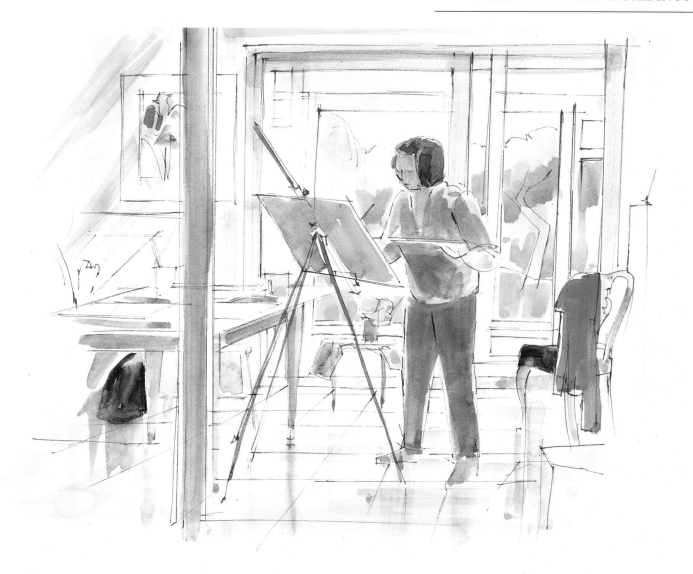

VANISHING POINTS

We have seen that the parallel sides of a road converge to a single vanishing point on the eye level. The same effect can be seen in the side of a building that is receding away from you. The lines of the top and base of the wall, the top of the roof, the top and bottom of doors and windows, which are in fact horizontal and parallel to each other, will look as if they are converging. If extended, these lines will meet at a vanishing point on the eye level. When you can see two sides of a building set at an angle to you, the lines formed by each wall, if extended, will converge towards a different vanishing point on the eye level.

Depending on your view of the buildings and the type of structure, there can be many vanishing points, but they all fall on your eye level.

Drawing imaginary villages can help you to understand perspective. When drawing from life, farm buildings are a good subject to start with as they are often relatively simple structures. Check your lines by holding up your pencil at arm's length or use cardboard angles (see page 89). Remember, if your drawing is accurately observed and measured it will look correct. However, you may need to check it by drawing on direction lines as shown here.

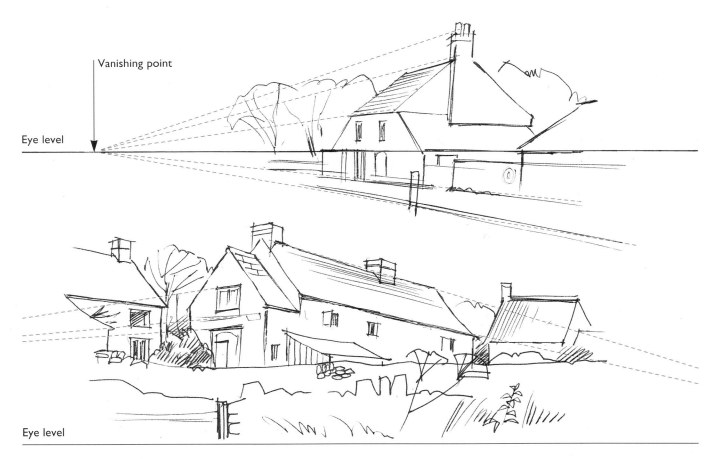

Vanishing point

Eye level

Eye level

Top Lines extended from the front of the house converge on a simple point at eye level. Notice that receding lines above eye level run down to the vanishing point; those below run up to it.

Above The low viewpoint means that all the perspective lines in the building recede down towards the eye level. Sometimes, like here, the vanishing points occur right outside the area of the drawing.

Tip

Builders usually work to geometric shapes, such as squares, rectangles, triangles and circles. Try to put yourself in the place of the builder when constructing your shapes.

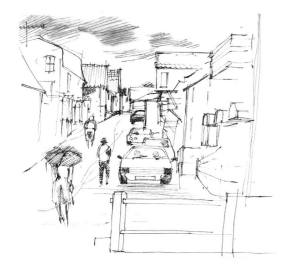

In this pen and ink sketch, the road and most of the buildings on either side converge towards a single vanishing point at eye level. The scale of the cars and figures diminishes towards the distance.

DRAWING BUILDINGS

Buildings provide fascinating subjects for the artist, but it is the one area where it is quite difficult to get away from considerations about perspective. There are certain architectural features – such as arches and bridges – that can be quite difficult to draw. It helps to be able to find the centre of these features, and that can be done by constructing them geometrically.

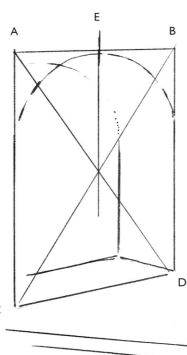

Left To find the centre of an arch, measure its width and height and draw a rectangle in perspective. Join points A to D and B to C. Where these lines intersect, draw a vertical line. This will give you the central point (E) from which you can draw the curve of the arch.

Right The same technique can be used to find the position of a roof gable on a wall that is turning away from you.

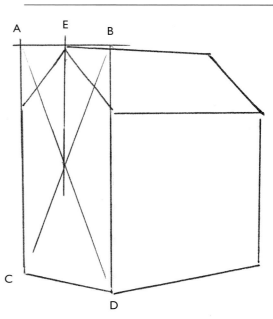

Below When drawing bridges, it can help to see the arches as being contained within a rectangle in order to help you establish perspective.

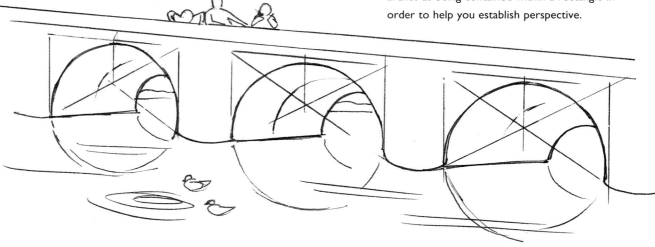

Towns can be busy, or even hazardous for the artist, so when drawing buildings in a built-up area choose your viewpoint with care. Work in the usual way: decide on your subject, and your eye level, then block in the main buildings, carefully noting distances and angles, before putting in smaller features and details.

Sunlight and shadows add drama, shape and tone to a composition. The changing light during the day can make quite a difference to shadows. Decide on a time of day, sketch the position of the shadows, and work from the sketch, or return at the same time next day.

If you plan to do a full-scale drawing, make several visits, and make some preparatory sketches before deciding on one particular aspect. Be prepared: make mental notes when you walk around, and try to avoid going in cold. Allow sketchbook drawings to go over two pages if they need to, and leave plenty of space around your image.

Experiment with different media: line and wash, brush, and pencil drawings. Include whatever interests you about the subject, including trees, people and details of street furniture, such as seating and street lighting.

LINCOLN CATHEDRAL

A light pencil sketch was made of this subject before the brush drawing was made using diluted Indian ink wash. Dramatic, sharply contrasting shadows in the road and detail in the trees define the foreground, while the distant tower is less well defined and in a paler tone. The road narrows to the distance, where a small group of figures creates a focal point and human interest and scale.

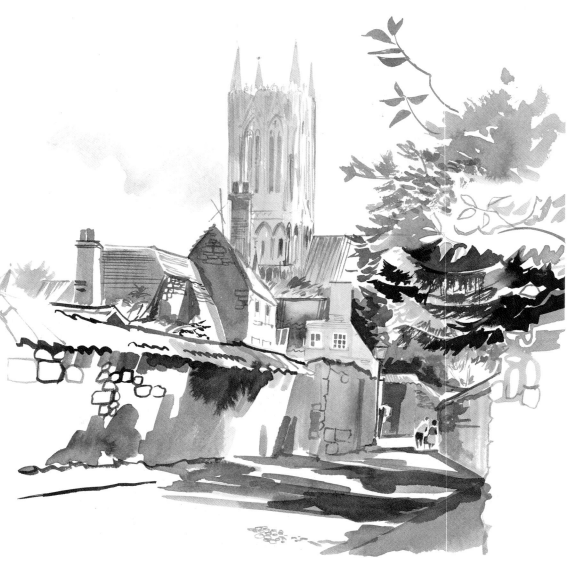

Angles

Use cardboard angles to measure and transfer angles from your subject to the drawing. Cut two rectangular strips of cardboard and secure them with a split pin, so that the strips can be easily adjusted to the angle required.

Right The eye level is low in this drawing, and the view looks up at the houses on a hillside. Most of the houses are viewed square-on, although the roof gables on the left are seen in perspective. Line and wash lends itself well to buildings.

Below Eye level in this drawing is also low – the roof on the house on the right is barely visible. Figures help to give scale to this picture.

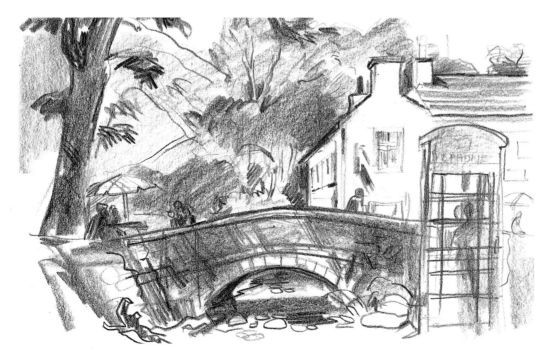

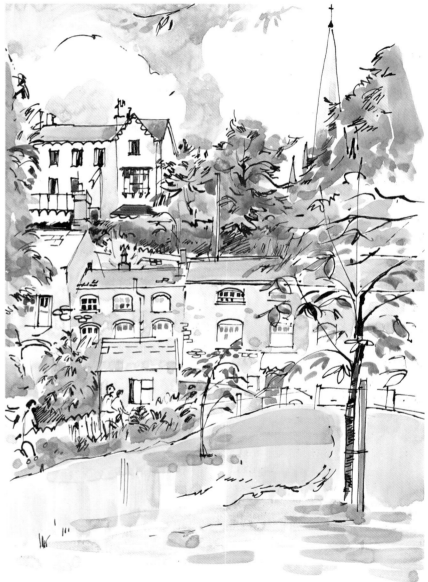

HIGH STREET

There is usually a lot of life and interest in a town street scene, but before you become absorbed in drawing details, remember to block in all the main shapes and check the perspective.

This drawing was made partly on site and partly later in the studio from reference sketches and notes. There is perspective in the pedestrian crossing, but most of the buildings on the opposite side of the road are viewed square-on and so perspective is hardly featured here. A drawing in pencil was made first, followed by a line drawing with waterproof fibre-tip pen; finally, light colour washes were laid.

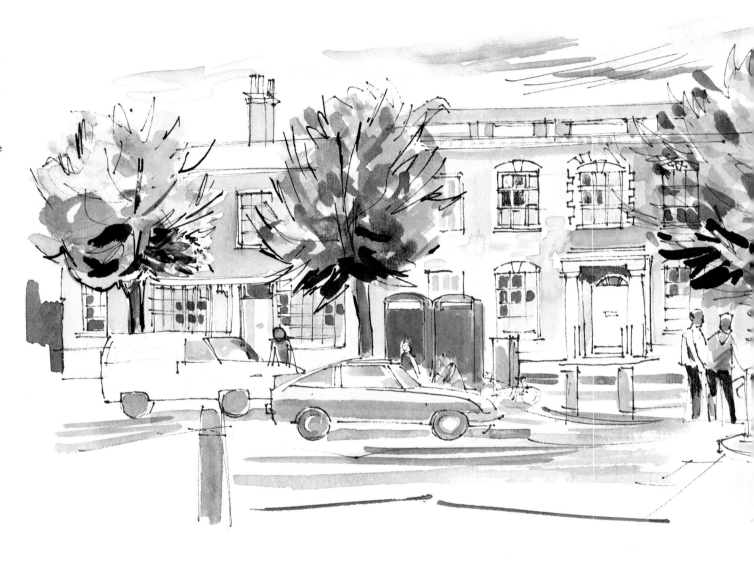

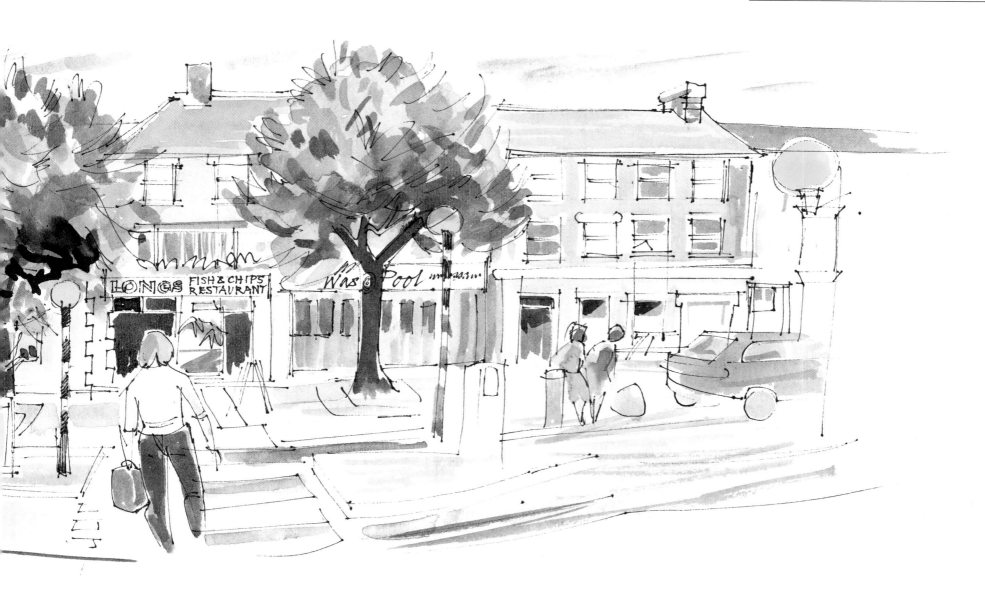

Drawing People

If you continue to approach drawing in the way you have learnt in the previous lessons, you will find that drawing people is not as difficult as you might think. We are all familiar with the human figure and we know that, even if there are peculiar characteristics, there are common features. What we have to do is to get all these things in the right places – and this means starting by looking for the large shapes and direction lines, and getting them correct in relation to one another.

PROPORTION AND STRUCTURE

It is useful to have an idea of the general proportions of the body. Taking the head as a unit of measurement, it can be said

that the normal human figure is approximately seven or eight heads high. Measure other parts of the body and see how they relate.

Consider the function and underlying structure of the human body – the bony skeleton (skull, rib cage, pelvis, shoulder blades, leg, arm, hand and foot bones), the shape created by the muscles, and the soft covering of flesh. This will help to avoid figures appearing rubbery, and make them convincing, living, dynamic structures.

Aims

■ To understand the basic shapes and proportions of the human figure

■ To draw figures in motion

■ To draw portraits and self-portraits

■ To study the features of the face

■ To compose a figure drawing

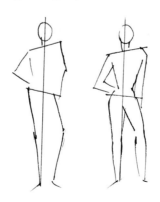

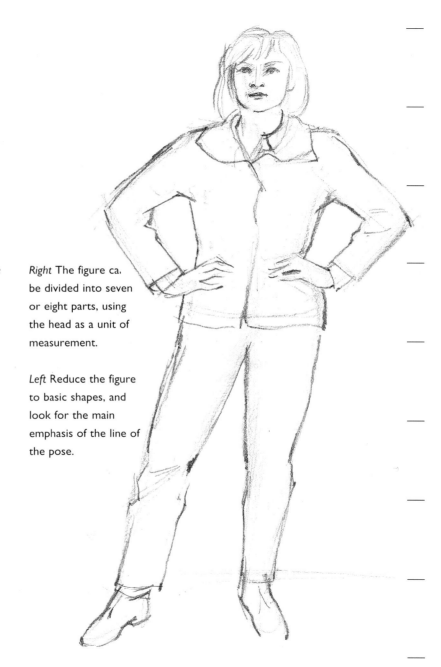

Right The figure can be divided into seven or eight parts, using the head as a unit of measurement.

Left Reduce the figure to basic shapes, and look for the main emphasis of the line of the pose.

SIMPLIFYING FORMS

Persuade a friend to model for you and ask them to sit or stand in a comfortable pose. Use cartridge paper and a soft pencil. Look at the figure closely for some time and decide how he or she is standing and whether the weight is distributed evenly or not.

Decide what shape the figure makes, and simplify the forms to large basic shapes.

Sketchbooks

Make small sketchbook drawings of figures whenever you can. Keep to the essentials, with no attempt to draw detail. Hands are often left out in this type of drawing.

Notice how all the parts relate. Start by drawing the head, add the line made by the angle of the shoulders, pelvis and vertebrae, then add legs and arms, constantly checking the proportions.

Once you have identified the main shapes and directions of the forms, you can start to firm up the lines and begin to establish general areas of tone before you arrive at the point when detail can be added.

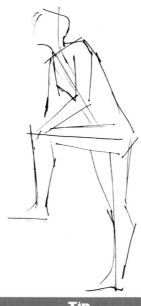

Tip

Make a study of anatomy from reference books or a skeleton for a thorough understanding of the way the body works — it will help your drawing greatly.

Left Quick sketches can help you to determine the general directions of the body.

Right Having determined the lines of a pose in a small sketch, you will feel more confident about drawing the model at a larger size and in more detail.

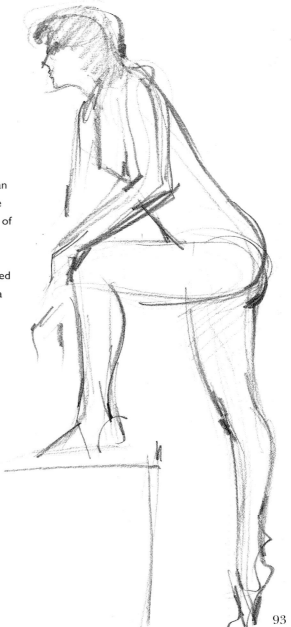

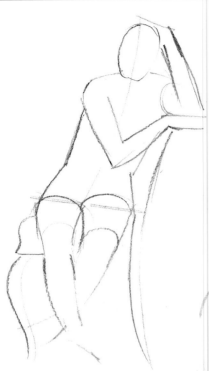

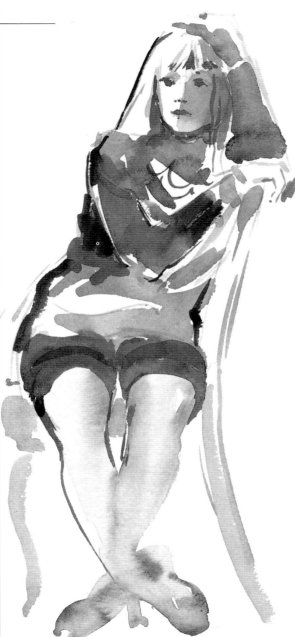

Foreshortening can be a problem when drawing seated figures, but if you regard the upper leg as a cylinder in perspective, and remember to measure correctly, you should overcome this.

LIFE DRAWING

Drawing a clothed figure becomes easier when you know how to draw a nude figure. You realise why clothes fold in the way they do, and your figures will look more convincing. Study of the standing figure, both front and back views, will help you to gain a clearer understanding of muscles and bones.

There are many life drawing classes, and if you are serious about drawing the figure, it is worth enrolling with one.

Generally the session starts with several very short poses (about two minutes), which will help you to warm up, and to develop your observational powers, as you will be forced to make very fast decisions. The length of other poses may vary from five minutes to several hours, giving you more time to investigate line, tone and different media.

The pose on the opposite page was drawn in about an hour, but it is important to remember that no two people will draw at the same speed.

Poses will be varied: standing, sitting and reclining; and you will see them from all sorts of views, some of which may be very difficult, where perspective makes the foreshortened forms appear quite strange when drawn.

Tip

Standing at an easel will help you to have a better view of the model. With your board firmly supported and vertical, you can take measurements more easily. And it allows you to stand further back to make sweeping strokes. It also encourages you to walk away from your drawing and to assess it more critically.

STEP 1

Start by making sweeping lines to capture the essence and main direction of the pose. If the model is seated or reclining, decide what kind of shape the whole figure makes and work within it.

STEP 2

Check measurements and proportions, and see that parts relate across the whole form. Notice how muscles create subtle curves.

STEP 3

When the main shapes have been established, look at the quality of the line of the drawing, and see how you can use it expressively. Add tone to describe the shape more fully. Include some background details to put the figure in context.

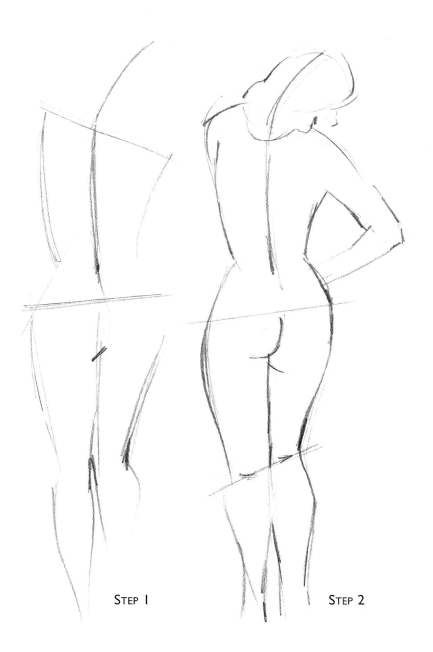

STEP 1 STEP 2

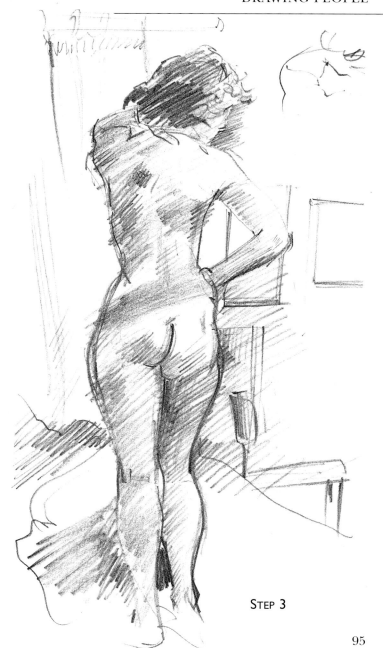

STEP 3

CHILDREN

Children make delightful models if you can get them to stay still. You will probably have to make several sketches before you capture the essence of the pose.

DIFFERENT PROPORTIONS

Drawing children is not so very different from drawing adults: one just has to realise that the proportions are different, and they vary depending on the age of the child. Using the head as a unit of measurement, in general a young child's head is larger, in proportion to its body, than an older child's head. A two to three year old, for instance, will be about four or five heads high; however, a twelve year old can be adult height (up to seven heads). Small children have plump hands, limbs and feet.

Babies make wonderful subjects, and will stay still quite peacefully when sleeping or feeding. When drawing babies, notice how large their eyes are, and how they are placed quite wide apart.

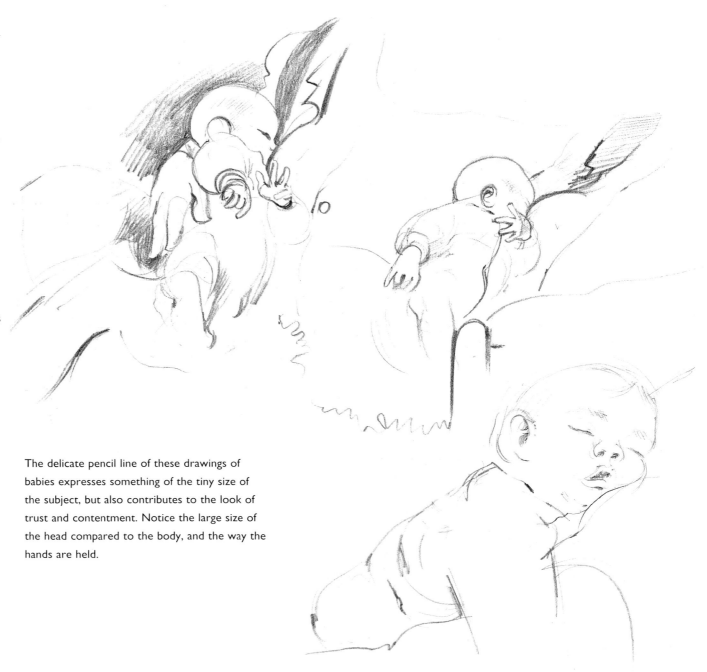

The delicate pencil line of these drawings of babies expresses something of the tiny size of the subject, but also contributes to the look of trust and contentment. Notice the large size of the head compared to the body, and the way the hands are held.

This young girl was so absorbed with sewing on her machine, that she made a good model for a sketchbook drawing. A loose pen and Indian ink line describes some of the shapes, while hatched tones were used to indicate the general area of the arm and chest.

Left Toddler with a toy duck, drawn with a fibre-tip pen.

Above This little drawing in pencil was later incorporated into a watercolour painting. Be ready at all times with your sketchbook!

A sinuous pencil line was used for this drawing of a girl reading.

GROUPS AND MOVEMENT

Figures within groups usually relate to each other or interact with one another in some way. A group of runners, for instance, is united in its action and the direction it is facing, while a group of people look at each other when talking. This is important to remember if you want your drawing to be a convincing whole, rather than an assembly of disparate elements.

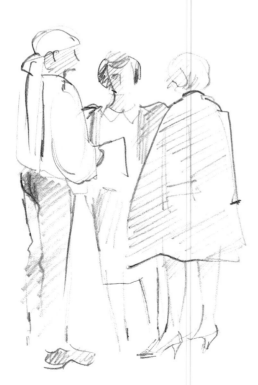

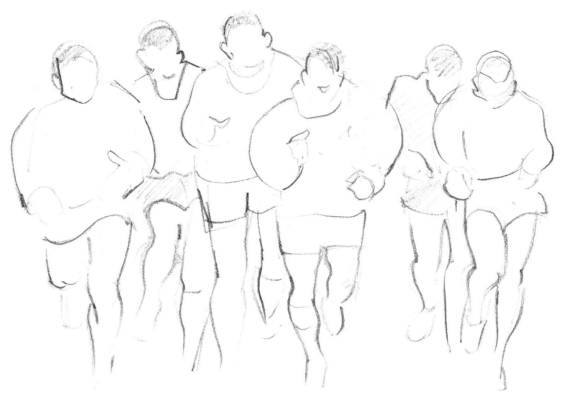

Use your sketchbook to make drawings of groups of figures and figures in action. Pencil drawings of a group of joggers (*left*), and of three people in conversation (*far left*).

Moving figures are fun to draw, but you have to be very quick to record the movement. If you are drawing a movement that is repeated, take the time to look hard before you draw to absorb the 'pose', then try to capture the essence of the movement with sweeping, swinging lines – don't fret if you make mistakes: just start again. Try to think of the idea that intrigued you in the first place; it could be the movement or the charm of the figure. Find a way to express how you feel about the subject.

If you are working from a model, you could get your model to walk in slow motion and stop when necessary. Alternatively, make numerous drawings of people walking about and compile a drawing from these.

Tip

You have to work very quickly when drawing a figure in action, so it is best to forget details such as faces, feet and hands, and to concentrate on angles and the general shapes.

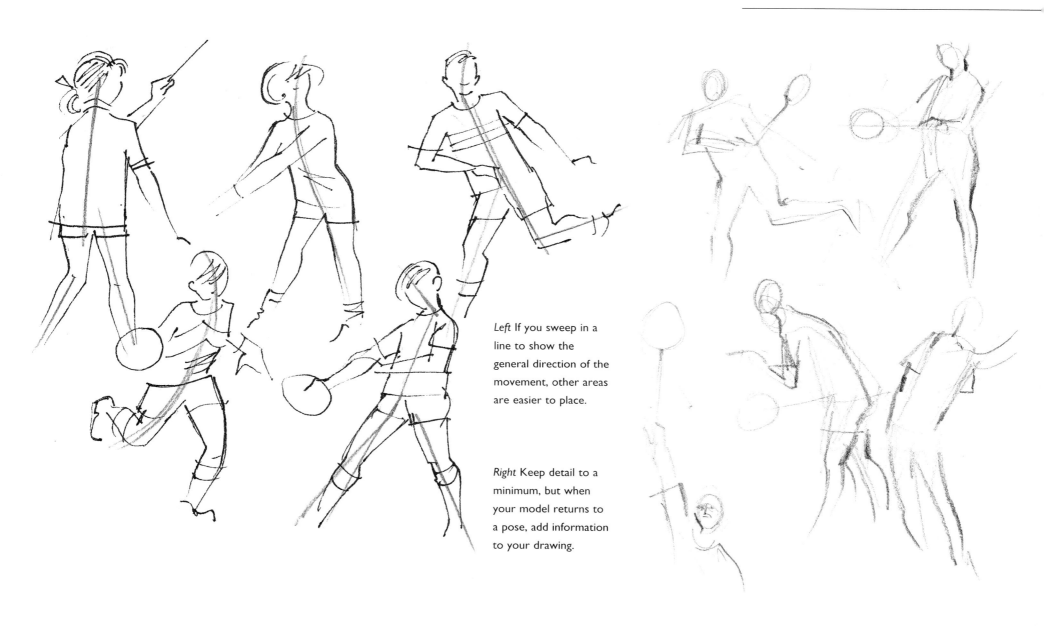

Left If you sweep in a line to show the general direction of the movement, other areas are easier to place.

Right Keep detail to a minimum, but when your model returns to a pose, add information to your drawing.

PORTRAITS

Portrait drawing is a real test of your powers of observation. To be able to get a likeness is a combination of accurate drawing skills and being able to capture the essence of the sitter. Human faces are similar in obvious ways, but even the thickness of a pencil line can shift the balance between a resemblance to the sitter and not quite achieving it.

There are various ways to start drawing heads. If you are a beginner, a straightforward full front view is the easiest. As always, look for the main shapes and relate the features to one another, taking particular notice of the distances between the eyes, the eyes and nose, the nose and mouth, and the position of the ears.

Each artist develops his or her own way of working, but the proportions and characteristic features are always important. You could start by drawing an oval for the face and fitting in the features, adjusting as you go. Alternatively, start with the eyes and work down and around the face. Another approach is to decide on the main characteristic of the face and work from there.

When drawing a portrait, it is important to remember that the face is only a part of

Above Notice the change in the position of the features as the head is bowed, or looks up.

Right Check the proportions of the face. The space between the eyes is approximately the same width as the eye. The top of the ear is on a level with the eyes. Compare the length of the nose to the distance between the eyes and mouth.

the head, which is supported by the skull – a fully three-dimensional object. As the angle of the head changes, so does the position of features of the face (see examples above).

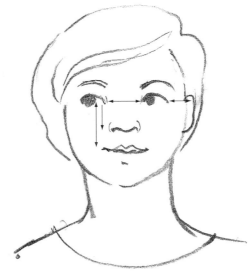

Practise drawing portraits wherever you are: in the street, on the train, or at home. Keep a sketchbook with you and take any opportunity to capture a likeness.

DRAWING A PORTRAIT

Find a willing sitter and seat him or her comfortably. Here the sitter is seen in a three-quarter view. Study the sitter and decide on the composition with the help of sketches, noting the direction of the light. Then begin to sketch in the main shapes.

Notice the shape and angle of the head (remembering the solidity of the underlying skull) and how it is set onto the column of the neck and the shoulders. The features of the face are set onto the basically oval shape of the face. Begin to construct the face, marking a central line for the position of the nose and mouth. Approximately halfway down the face make a mark for the eyes, then divide this again by two for the position of the nose and lower lip. (Remember that these are only approximate measurements.) Go on to place the ear and the hair, and also the shoulders. Continue to sketch in the main angles and shapes. Draw very lightly, so that you can erase mistakes and draw again to get the features as you wish.

Tip

Look at your portrait drawing in a mirror when you have finished. Any defects and inaccuracies will become apparent when they are reversed in the reflection.

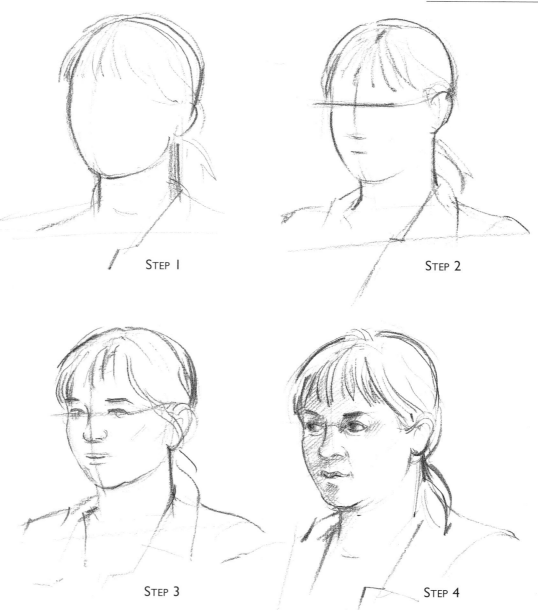

STEP 1

STEP 2

STEP 3

STEP 4

STEP 1

Draw the main shapes of the head, neck and shoulders and lightly mark in the centre of the face to find the position of the nose.

STEP 2

Mark a line for the eyes, which is approximately level with the top of the ear. Indicate the positions of the end of the nose and the mouth.

STEP 3

Draw in the eyes and eyebrows. (Consider the space between the eyes; there is usually enough space for another eye.) Measure the distance from the corner of the eye to the nose.

STEP 4

Define the shape with tone. The top lip is clearly defined by the light, the bottom lip is more obscured by shadow. The upper part of the nose is a bony structure, the rest is cartilage.

SELF-PORTRAIT

Portraits demand the very particular skill of getting a 'likeness' and of capturing character. A self-portrait can perhaps be a more appealing and forgiving subject; it is certainly easier than hiring a model or persuading a friend or relative to sit for you, and you only have to please yourself.

Many artists, from Rembrandt to Van Gogh, have made self-portraits, and a study of those by Rembrandt provides an interesting record, not only of the change in his physical appearance through his life, but also the development of his style.

SETTING UP

It will take a while to work out how you are going to sit or stand, and how you are going to arrange the lighting. A soft, natural light coming from one side is preferable. For this, sit near a window. Daylight bulbs will enable you to work in bad light conditions, and if you want dramatic shadows, use a spotlight.

The main difference between drawing a portrait of someone else, and one of yourself, is the practical side of things.

You want to avoid having to change the position of your head as you draw, so it is best to start with a front-facing self-portrait. Place the mirror in front of you at the

1

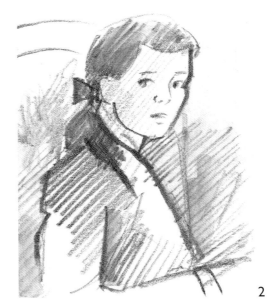

4

2

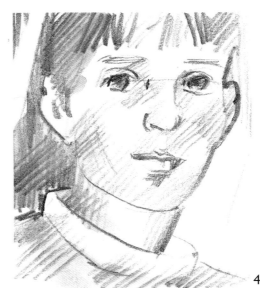

3

1 Full face, head and shoulders. The subject is sitting with the mirror in front of her and the board to the left. Hats can add interesting shadows.

2 The mirror is at an angle to the drawing board so that the head hardly has to move at all; only the eyes need to move from the mirror image to the image on the board.

3 A nearly full figure self-portrait. A full-length mirror is needed, and enough room to work comfortably at an upright easel.

4 Cropped heads can show more detail and often make interesting compositions, as well as giving the drawing a feeling of intimacy.

height you wish to work so that you can look from your mirror image to your paper by moving only your eyes.

It is important that the mirror is large enough. And, if you have two easels, set up your drawing board on one and the mirror on the other so that it can be moved around the room easily. A shelf will do just as well, but does not allow you such flexibility in setting up a pose. You may wish to use a second mirror to give yourself another view of the subject. It is only too easy to forget that there is another dimension. With any kind of life drawing you need to be fully observant and to know what your model looks like from all angles.

You may also wish to experiment with different materials. Charcoal and conté crayon are sympathetic media, while pencil is more exacting for a subject such as this. It is certainly best to start in monochrome before progressing on to colour.

Tip

The nearer the mirror is to you, the more detail you can see. Taking measurements close up, however, can be difficult. You may wish to try using a pair of callipers (an instrument with two legs hinged at one end, similar to dividers) to measure dimensions from your head, rather than from your reflection.

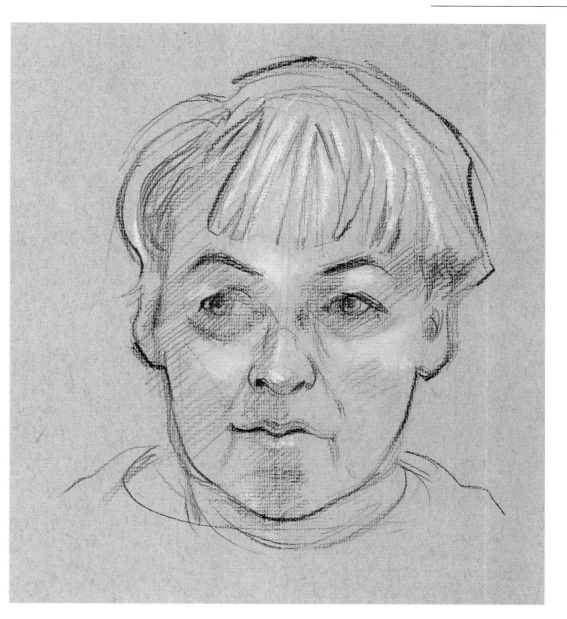

This self-portrait was drawn on green Ingres paper, using black conté pencil and a little white conté for the highlights. Shadows are lightly hatched in, and features are emphasised by the fall of the light. The mass of the hair is suggested by just a few strokes.

I placed the mirror (which was about 76x30cm/24x12in) directly in front of me at eye level. The drawing board was held vertically on an easel, about 30cm (12in) in front of the mirror and to one side of it, so that I could look from the image to the drawing without changing the position of my head.

Left Pen and ink is a demanding medium to use for a portrait as there can be no erasing, so proportion and distances have to be carefully observed.

Below A sketch of a girl who was happy to pose. The drawing is based on a basic oval shape, and interest was added in the position of the hand and the inclusion of the shoulders. It was drawn with conté pencil, and includes a little shading to model the features in tone.

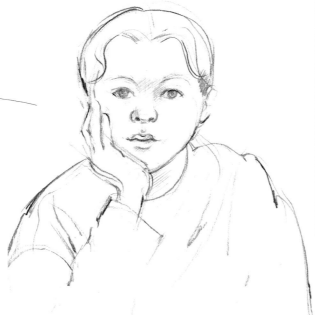

Tip

Consider the face as a three-dimensional shape, made up of a series of planes – the forehead, the nose, the cheeks, the chin and jaw – which are revealed by light and shade. Distance, angles and shapes are keys to determining these planes.

A serious attempt at a portrait of a serious young woman who sat very still for me in four twenty-minute poses. The drawing was made in conté pencil on Ingres pastel paper.

FACIAL FEATURES

Look closely at the features of the face and do not be tempted to generalise. Notice the structure of the eye, and the way the lids cover the eye. See how eyebrows can vary; they can be almost linear, or strong and bushy. Ears are interesting – lobes can be large and fleshy or practically non-existent, and some men's ears are very large indeed.

Male and female faces differ in detail and need to be understood. Women's mouths are softer, and the groove between the nose and mouth is less defined. Men's mouths are usually thinner and more angular, and cheek bones and jaw lines are very important.

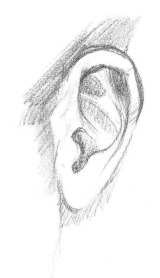

Always treat hair as a mass – remember it grows from the head (it does not sit on top of it) and often can be very thick indeed. Look for the main shapes and place any detail last, considering the texture and the sex of the sitter.

Draw details of the face in various media and find which one best conveys the expression of the sitter. Examples of pen and ink, pencil and conté drawing are shown on this page. Some are sketches, others are more serious studies.

HANDS AND FEET

When sketching figures, details such as hands and feet are often left out. However, when undertaking more serious drawing, life drawing or portraits, hands are important as they denote character and add to the pose. The inclusion of the feet (whether bare, or in shoes) in nude or clothed figures completes a drawing, and often adds more to the balance of a standing pose.

There is no excuse for not practising drawing hands and feet as you can always use your own as models to draw from. Draw your non-drawing hand, and your feet viewed from above or seen in a mirror.

Hands and feet differ with age and sex, but general structure is all important. As always, look for the main shapes of the subject before describing details.

Make your hand do something – hold a tennis ball or a book – and make studies of the hand from all aspects: back, front and side. Draw in line only, using a soft pencil or a thin stick of charcoal.

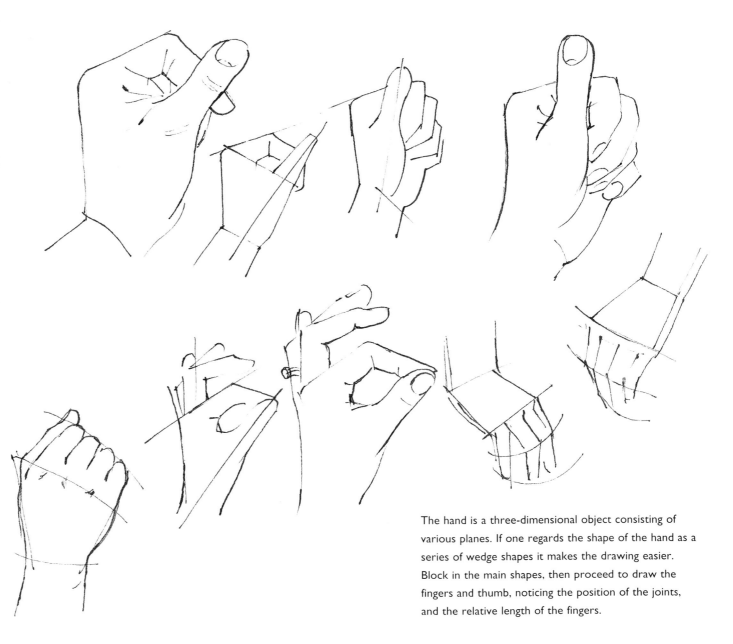

The hand is a three-dimensional object consisting of various planes. If one regards the shape of the hand as a series of wedge shapes it makes the drawing easier. Block in the main shapes, then proceed to draw the fingers and thumb, noticing the position of the joints, and the relative length of the fingers.

Feet are strong, flexible weight-bearing structures, an extremely complicated set of bones, best understood by looking at the skeleton of the foot.

Notice the way the foot joins the leg at the ankle. Make sure that the toes are the right size, and that they lie next to one another comfortably.

When drawing feet in shoes, remember that there must be room for the foot inside. Look back at pages 32-3 in Lesson Two, where studies were made of a shoe seen from various angles. Use the same approach here to construct the shape by drawing a central line of reference, checking the general direction of the lines and planes.

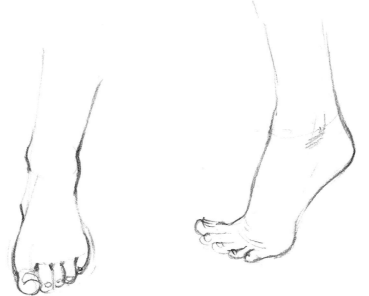

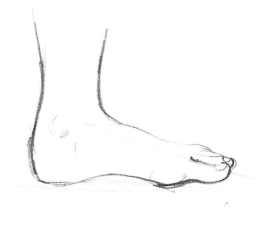

Make studies of other people's feet, or of your own viewed in a mirror, both with and without shoes. Draw the main shapes before adding detail.

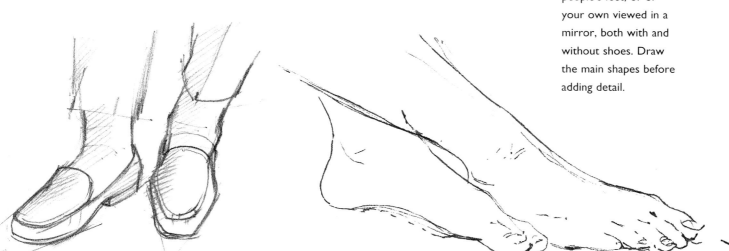

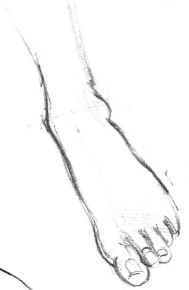

DRAPERY AND CLOTHES

To understand how to draw clothes on the body, you must know what happens to material when it is wrapped or folded or hung. The most important clues are often given by what is underneath the visible surface – not only the form of the figure, but also what happens to the folds themselves as they curl out of view.

Try to familiarise yourself with the characteristics of different types of fabric; to understand the way silk will drape in comparison to wool, for instance, and how different fabrics can be represented by texture and pattern. Hang a piece of fabric or clothing on a peg and make some studies of the folds. This was a standard exercise for artists' apprentices in Renaissance studios, and is a good example to follow.

Drawing the folds of a curling ribbon is a good introduction to understanding how they work.

A lightweight material falls into delicate folds.

A pattern will give clues to drapery. The dotted lines show what is happening to the pattern as it follows the folds.

Tip

Always imagine what happens to the folds when they are out of sight. Try to follow the line through the fold, even if you cannot see it.

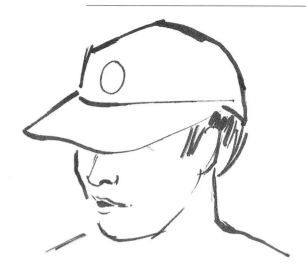

Right A hat must be drawn to look as if it is worn on the head, not on top of it.

Above Clothes that stretch and fold around the body help to indicate movement. Sleeves can show creased and pinched folds.

Remember that a collar goes all around the neck; it does not stop at the sides of the neck, and it must be seen to disappear.

Left A coat and hat on a hook makes an interesting study of a heavier weight material. Charcoal on rough paper emphasises the texture of the fabric.

Tip

Drawing historical costume at your local museum is great fun.

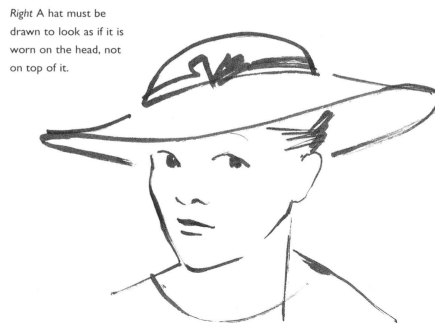

TWO-FIGURE COMPOSITIONS

There are probably some aspects of
drawing people which appeal to you more
than others. You may prefer sketching, or
have decided to study the nude, or would
like to learn how to draw portraits and have
already started to try to achieve a likeness
by studying the human face. At some point,
it is a good idea to make a more fully
worked-out study of a subject that you
enjoy. An interesting subject is a
composition that includes two figures in
close proximity.

Find two willing people to pose for you:
two friends, or a mother and child, for
instance. Your next step is to compose your
subject, finding the right arrangement that
reflects something of the relationship
between your models. Consider the setting
and the lighting. Make a number of
thumbnail sketches to determine the best
position to work from, and to decide on the
final pose. Consider different media; pastel
might be a good choice if you want to work
in colour. When you are ready, make a start
on your final drawing, endeavouring to
capture the pose with expressive lines.
Work at an easel if you can and position
yourself at a distance that allows you to see
the group as a whole.

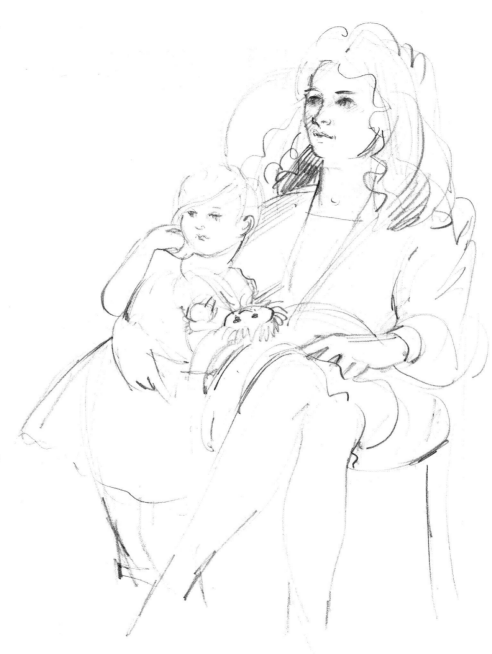

MOTHER AND CHILD
Several sketches were made before
the child moved into a position that
worked well for the composition, said
something about the relationship
between the two models, and in which
she was comfortable. It was important
to work quickly as the child did not
want to stay still for very long.

GRANDMOTHER AND GRANDDAUGHTER

A pencil drawing was made of the figures sitting by a river. Colour notes were also taken, providing useful reference when subsequently watercolour was added to the drawing in the studio.

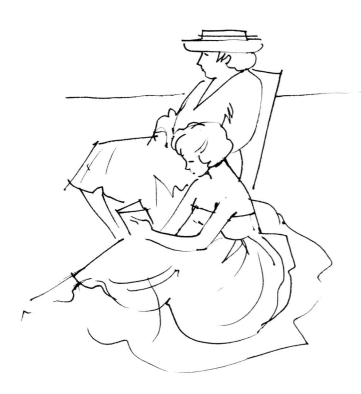

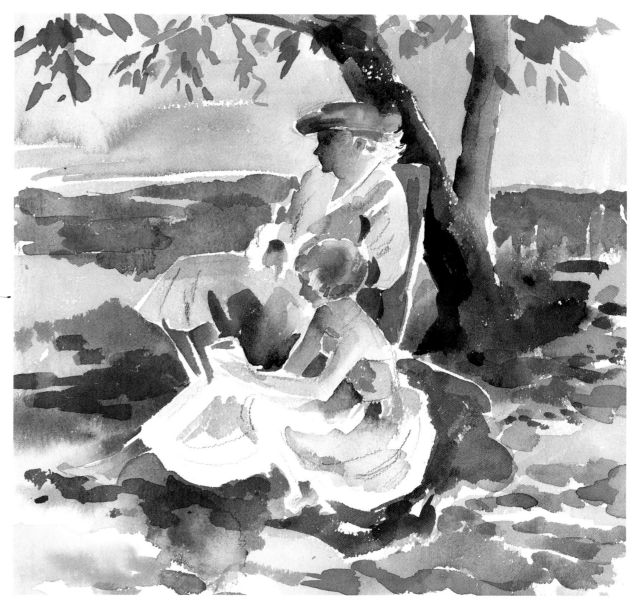

Using Sketchbooks

Sketchbooks are invaluable; take one wherever you go – you never know when you will need it. It will help to keep you in practice with your drawing, and will provide you with hours of enjoyment and a vast amount of useful information which can be referred to in the future.

There is a large selection of sketchbooks to choose from (see page 12). A small A6 sketchbook is particularly useful as it will go into a pocket or bag and you can carry it with you at all times.

Keeping a sketchbook will help your drawing to become second nature, and your observational powers will increase dramatically. The kind of drawings you make in your sketchbook can vary from the slightest notes to fairly detailed work. Sketchbooks are useful for reference, such as for note taking, and jotting down colour ideas and working drawings which can later be used to develop a fully worked drawing or painting.

Draw people when waiting at a station or airport; take your sketchbook to your town centre and study figures. Take it on a walk in the country, and draw trees and animals. Use it to collect details about windows, roofs and doors; and to record information about lighting and colour.

Sketchbooks are a useful place to work out compositions, so always remember to carry one with your drawing and painting equipment.

Date your drawings, and keep your sketchbooks. You will be surprised and delighted when you return to them – they will conjure up memories that photographs often omit. Keep any loose sketches in a file to keep them in order. You will be able to see how you have improved, and it will remind you of techniques and ideas that you have had in the past, which may provide fresh inspiration.

Aims

- To encourage you to use sketchbooks on a regular basis
- To increase your powers of observation
- To record details for future use
- To work out compositions in the field
- To study details of trees, animals, birds, figures and boats

Tip

If you want to travel light on holiday, all you need is a sketchbook and pencil, and a fibre-tip pen.

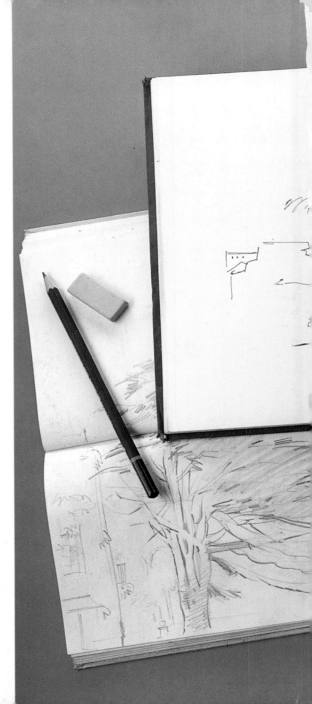

Right A selection of pages from some of my sketchbooks.

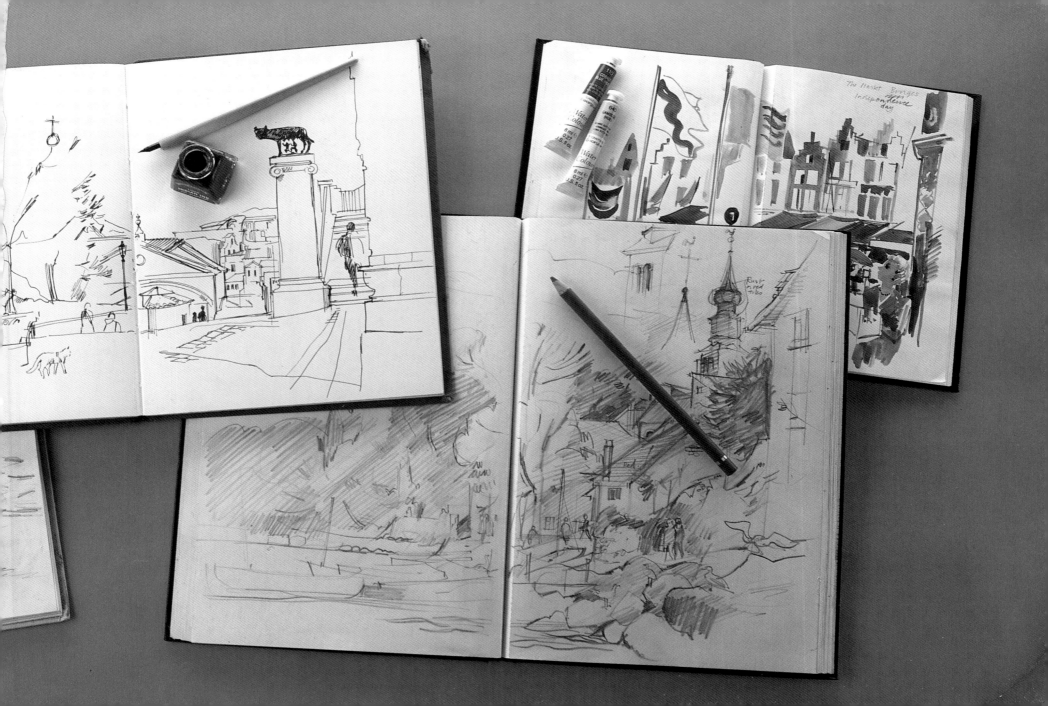

LANDSCAPE SKETCHES

Sketchbooks are very helpful in landscape drawing, and being able to get in the habit of making compositional drawings at speed is something we all aspire to. Some aspects of landscape composition have already been discussed on page 68. On these pages are several different types of drawings, which will encourage you to use your sketchbook in many different ways.

Your compositional sketches can be quite small (approximately 9 x 12cm/3 x 4in is quite large enough); and be prepared to change and adapt your first ideas. With such a small sketch, it is easy to repeat the process at any stage if you are not satisfied. Select your viewpoint and format, establish your eye level, note the main features and block them in; think about the direction of

light and note the shadows, if any. Put in the main areas of tone, noting the darkest and lightest areas. Lastly, add any important details, consider the composition, the centre of interest, and compositional lines; make any changes necessary.

Annotate your drawings with written notes, anything that will help you to remember details about the scene. Be fairly precise about your description – red, for instance, could be dark or light, pinky-red or orange-red.

Colour sketches are also useful. Use coloured crayons (watersoluble crayons are particularly useful), pastels or watercolour. You may also wish to take photographs to record details, or scenes, but these should only be used to back up information that you have recorded in a drawing.

Left Watercolour sketches of clouds record the fleeting effects of skies.

Right This sketch concentrates on the patterns created by light and shadows.

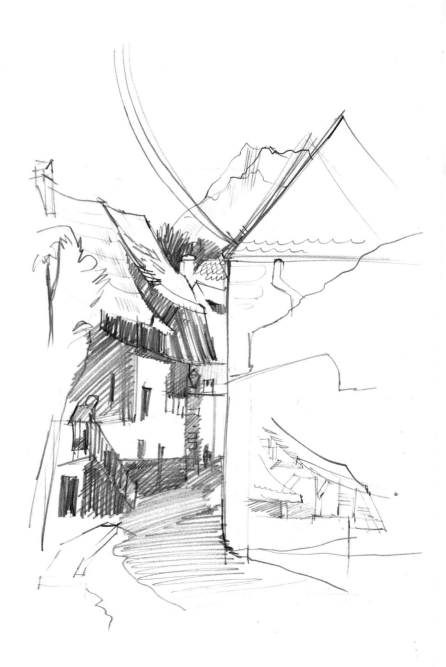

Left These sketches are shown at their actual size. They are quick to do and help to decide your composition and main tonal areas within a defined shape. At this scale, it is very easy to correct or start again.

Right Colour memory can often let you down, so small colour sketches such as these can be a useful 'aide memoire' when working on a larger drawing, or a painting of the subject.

Tip

If you have forgotten to bring a viewfinder (see page 65) with you, improvise by making a window with your hands to help you to focus and select a view.

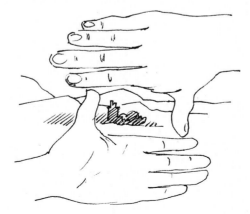

Tip

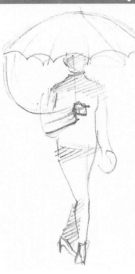

Figures add life, scale and interest to landscape sketches. Try to capture the pose with a rapid line and build up a collection of figures which can be referred to later, and added to a composition based on another drawing.

Above Take your sketchbook with you on holiday to record features in the landscape that you might not find at home. This little pen and ink sketch made beside a canal in Belgium provided the opportunity to make a study of a windmill. Notice the bold treatment of light and shade on the trees.

Right Two figures sitting on a wall on a village street add life to the scene and provide a centre of interest.

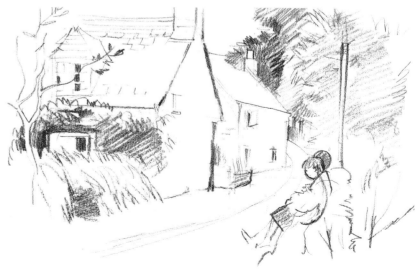

Right Handwritten notes add to the information in a sketch, reminding you of aspects that were important to the scene at the time.

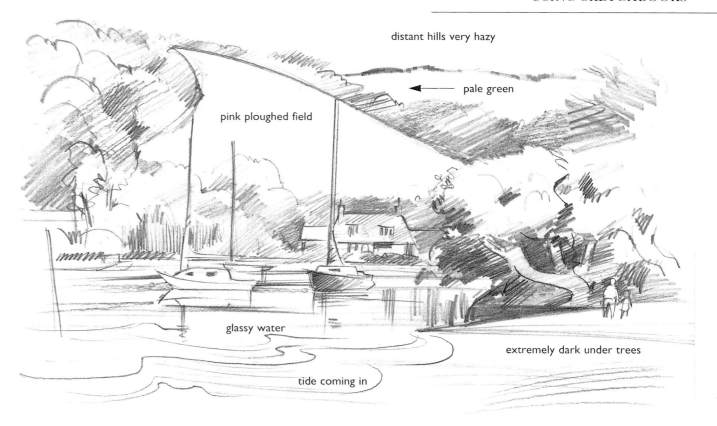

distant hills very hazy

pale green

pink ploughed field

glassy water

extremely dark under trees

tide coming in

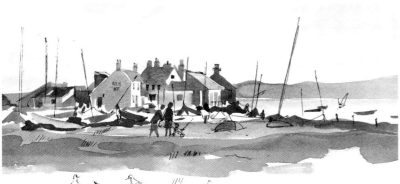

Left Your sketchbook can be used for more fully developed drawings. This line and wash drawing was made in a car on a cold day in Hampshire. I wanted to record the shapes of the boats and the buildings and the colours of the sky. A pencil drawing was done first to establish the main areas, and then watercolour washes were applied.

TREES

Trees are a common feature in the landscape. Try to make a close study of them in your sketchbook and learn to identify them in any season. Make studies from a distance of their general habit and then get closer to make detailed studies of leaves and bark. Try to become familiar with some of the most common species, such as oak, beech, silver birch, poplar and horse-chestnut.

In winter, a tracery of branches is a very different challenge for the artist from a tree in full summer foliage with its vast canopy of leaves. Whatever the season you should start basically in the same way: take measurements, block in the main shapes and use tonal variations to help define areas of light and shade.

A tree in full leaf should be looked at with a view to massing in the foliage with strokes that give an impression of its appearance. It is a question of finding a shorthand for the texture.

Trees that are silhouetted against the skyline should have considerable attention paid to the outline that they make, while individuals within a group of trees might have less distinct edges, giving a more general impression of shape.

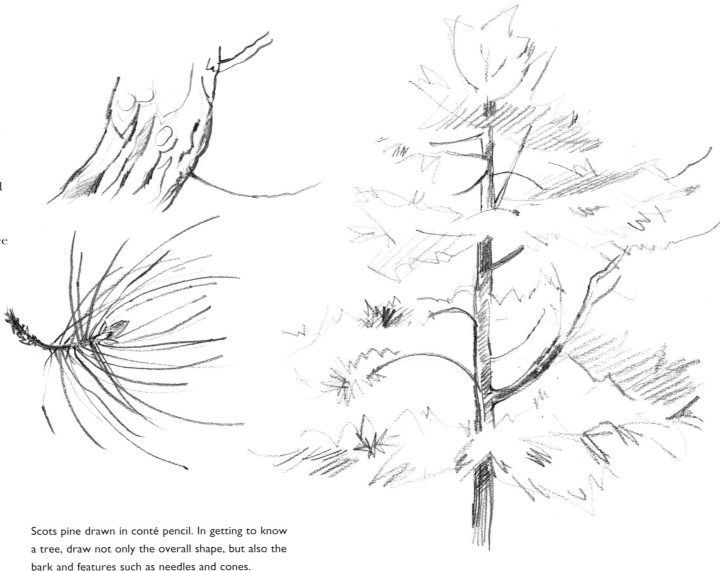

Scots pine drawn in conté pencil. In getting to know a tree, draw not only the overall shape, but also the bark and features such as needles and cones.

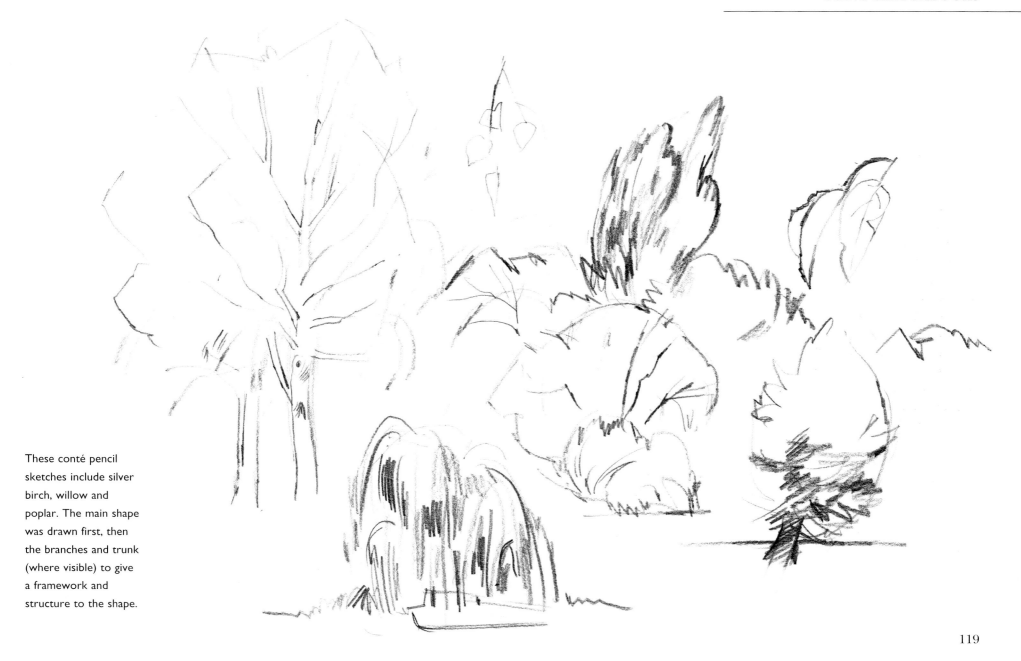

These conté pencil sketches include silver birch, willow and poplar. The main shape was drawn first, then the branches and trunk (where visible) to give a framework and structure to the shape.

ANIMALS AND BIRDS

How do we go about sketching and drawing animals and birds? They are always on the move – horses and cows walk towards us with curiosity, sheep stand still for a few moments and then run away, small wild animals such as squirrels dart off immediately. Zoo animals make fascinating subjects, and because of their strangeness may be a little easier to draw. Domestic animals, such as dogs and cats, are more likely to be obliging models; and sleeping animals present the least problems for the artist.

Try to imagine the skeleton of the animal; how are the legs constructed and how do they move? Look at the length of the neck, and the way the ears are set on the head.

Look for the character of the animal; is it sleepy or nervous? What is the texture of the fur or feathers? Would a different technique convey something about the character or texture of the animal? Try to work fast and to capture what you consider to be the most important aspect of the animal. If it moves, start another drawing, and don't give up!

Start by taking a soft pencil and a sketchbook, and look and draw and look and draw again! Be prepared to make many attempts. Look for the main shapes of the body, and to understand the proportions of the body to the legs and the head.

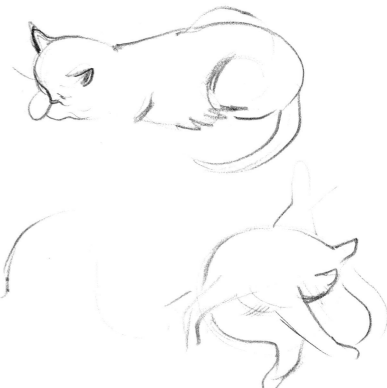

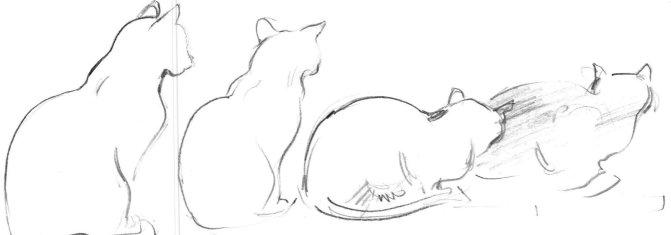

Cats are sinuous creatures. Look for direction of the spine, and study the angles of the legs. Don't forget to try different media.

When drawing birds it is sometimes helpful to start with an egg shape. The wings, tail and head can then be fitted onto this basic shape.

At a distance, feathers will be hard to distinguish. Indicate just a few very simply on the body to imply the rest. This will be much more effective than trying to draw them all over the body. Make some close-up studies of feathers that have been lost by birds to understand their shape.

Ducks are delightful to draw and only need a little bread to keep them happy while you sketch.

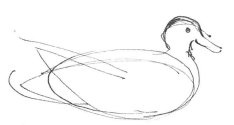

Start with an egg shape when drawing a bird's body.

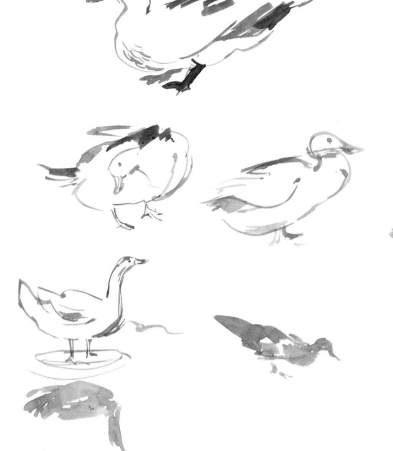

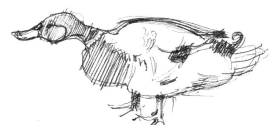

Horses and farmyard animals make wonderful subjects. If you sit or stand still for long enough the animals will become accustomed to you and might stay still. These animals were drawn at different times in different sketchbooks, using pencil and conté crayon.

Horses seem to be composed entirely of curving lines. When the horse moves, start on another drawing. Come back to a drawing when the horse resumes its original 'pose'.

Tip

An agricultural show is fertile ground for the artist with a sketchbook.

It was a rainy day on this visit to an agricultural show. The sky was grey and heavy, but this made the white coats of the animal keepers stand out well. The drawing was made in a watersoluble graphite pencil, with watercolour. There was no attempt at detail; these models were moving all the time.

BOATS AND REFLECTIONS

If you go to the sea for a holiday and have time on your hands, take the opportunity to draw the subjects around you. Beaches offer great scope: the sea, rocks, waves, people sunbathing, children playing. Harbours offer a variety of subjects: boats, fishermen, lobster pots, crabs, fish, anchors and rope.

Boats make interesting subjects, but they take some practice to achieve successfully, and your sketchbook is an ideal place for studies. Start with a simple boat such as the dinghy on this page; compare the height to the width (beginners often make boats too

short), and use construction lines when sorting out general proportions. It often helps to include a figure to establish scale in your drawing.

Once you have understood how a simple boat is constructed, go on to draw sailing boats, or fishing boats, which often have a cabin and other superstructures.

Boats are somewhat easier to draw when in the water than when dragged up on the beach, when the whole shape is visible. This poses a new challenge – that of drawing reflections.

Reflections need to be studied closely. They are affected by the light and weather and by the type of water. Mirror images will

appear in calm conditions, but water is often disturbed by ducks, boats or wind. It is also generally true to say that lake and river reflections are darker than the objects they reflect; the colour of the river or lake bed will make a difference too.

Water is fascinating and takes many forms. Oily reflections in harbours, the sea swirling around rocks, waves breaking on the shore – all need plenty of study to capture the mood and movement of water.

Reflections are essentially vertical, but they are disturbed by water movement, causing the image to fragment into broken reflections. This creates fascinating and unexpected patterns on the water.

Tip

If you are drawing on a beach or a tidal river, don't forget about the tide – many an artist has suddenly found themselves surrounded by water.

Fitting a boat into a box shape often makes the drawing easier (particularly when perspective is involved). Remember to look for the simpler shapes and notice the construction: the bow and stern are linked by a central rib or keel.

The empty expanse of beach – still wet from the outgoing tide – was transformed into an area of interesting reflected patterns of colour and shape created by the sailing boats, people and sky. Be ready with your sketchbook for any opportunities.

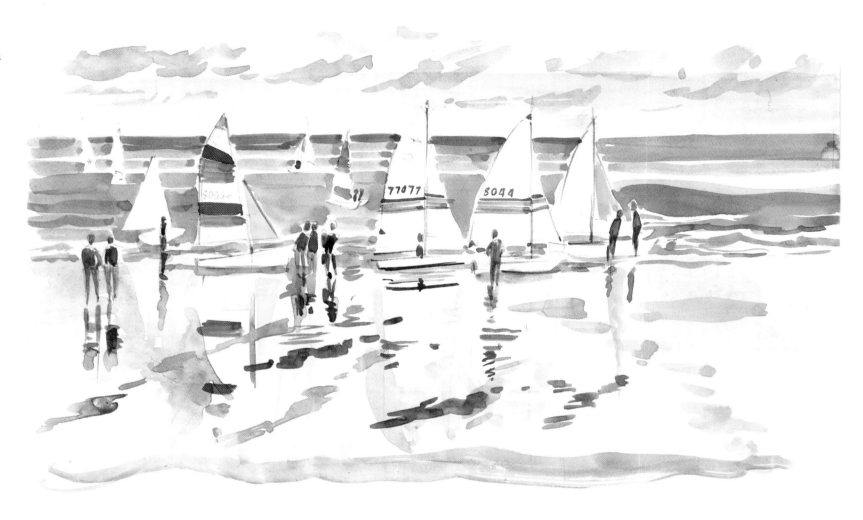

Final Thoughts

Drawing is a highly personal creative art, so try to use your initiative and work out your own original ideas. You will need to work hard and be disciplined, but it is a joy to be able to draw and this will stay with you for the rest of your life.

Drawing is a pleasurable activity which can be enjoyed purely for its own sake. It can also be used as a preparation for painting, whether in watercolour, acrylics or oils, or it might lead you to investigate one of the many printmaking techniques, such as lino cuts, etching, engraving or lithography. Some artists go on to become sculptors or potters – there are many routes to take.

Much can be learnt from a book – it is also very enriching to attend drawing classes, or perhaps to go on a drawing holiday, either at home or abroad. You might consider getting together with friends in a small informal group to go on drawing trips. This will provide impetus and stimulation as well as the opportunity to work alongside like-minded people and learn from each other. As well as local clubs, there are nationwide societies which welcome amateur artists and are happy to provide information and advice. And when you feel more confident about your work, you might consider showing it at an exhibition.

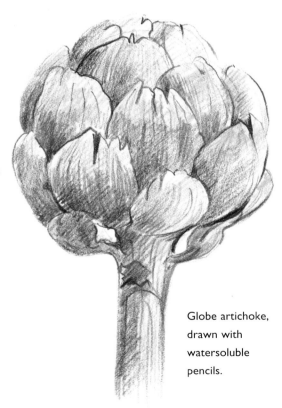

Globe artichoke, drawn with watersoluble pencils.

Storing, Mounting and Framing

I have encouraged you to date and keep your drawings. It is very interesting to review them from time to time and to chart your progress – and it may inspire you to pursue different ideas.

On a practical note, store drawings flat in a drawer or portfolio. If you have to roll them up, roll them loosely and keep them in a large tube. Remember to fix charcoal and pastel drawings and put sheets of tissue between pastel drawings to protect them.

A drawing can be transformed by being displayed in a mount or frame, and it is rewarding to see your own work hanging on a wall. Cutting a mount can be as simple or as complicated as you want to make it. You can simply cut a window in a sheet of mounting board (there is a wide variety of colours available – choose one to complement your drawing) with a craft knife held against a steel rule. You can make the cut with a bevelled edge, by holding the knife at an angle, or you could buy yourself a mount cutter. There is a wide selection of ready-made frames, or you could learn to frame pictures yourself (many classes are offered) and this is a lot cheaper than having it done professionally. The glass will protect your drawing, and this is a consideration if you have one that you feel particularly pleased with. Look at drawings in galleries or museums to get ideas about how to present your work to best effect.

GLOSSARY

aerial perspective the effect of the atmosphere on the way we see things in the distance: tones and colours become paler and less distinct.

blending creating a transition from one tone or colour to another by smudging or using a torchon.

cartridge paper a useful, general-purpose drawing paper.

charcoal drawing medium made of charred willow or vine twigs.

conté drawing medium made of compressed pigments, commonly in stick/crayon form, or as pencils; brown, red, black or white but also a wide range of colours.

ellipse a flattened circle – the shape a circle takes when it is seen in perspective.

eye level a constant level consistent with the level of your eyes.

fixative substance sprayed onto charcoal or pastel drawings to prevent them from smudging.

form the shape of a three-dimensional object, represented by line or tone in a drawing.

gouache opaque water-based paint.

grid lines in the form of a grid used to enlarge paintings and drawings.

hatching method of conveying tone by shading, using lines of various character. The effect can be intensified by working over the first lines with others drawn at a different angle (cross-hatching).

highlight the lightest points in a subject or a drawing.

linear perspective a system for representing three-dimensional objects and space on a flat surface. The effect of linear perspective makes objects look smaller as they recede into the distance.

local colour the actual colour of an object, unaffected by light or shade.

media an overall term referring to different methods and materials.

modelling describing the form of an object using tone or marks.

negative spaces the spaces between and around objects.

plumb line a small weight suspended on a string, which helps to find a vertical.

primary colours red, yellow and blue.

resist a substance, such as wax, which will repel a water-based paint.

secondary colours orange, green and purple; each is obtained by mixing two primary colours together.

sepia brown colour (of conté, watercolour or ink).

sight size a drawing done at the size that you actually see the subject by measuring the subject accurately against a pencil or similar instrument and transferring those measurements to the paper.

stipple dots of paint or ink which in a mass can form tone.

support the surface that is used to draw or paint on, also a drawing board.

thumbnail sketch a small preliminary sketch.

tone term given to light and shade falling onto a subject. Areas of light and dark in a drawing.

tooth the roughness of a paper surface.

vanishing point the point on the eye level where lines on the same plane converge and disappear.

viewfinder a small open rectangle through which subjects can be viewed.

wash a light application of watercolour or in

INDEX

Page numbers in *italics* refer to illustrations

accidental drawing, 37
accuracy, 24, *24*
aerial perspective, 84, *84*
aide memoire, 115
angles, 89, *89*
animals, 120–3, *120–3*
approaches, 36, *36*
arch, 87
atmosphere, 52, *52*
atmospheric drawing, 37, *37*

back lighting, 47, *47*
bamboo pen, 8, 61, *61*
birds, 121, *121*
blending, 41, *41*, 42
blotting paper, 55, *55*
boats, 124, *124*
Breakfast Still Life, 67
bridge, 87
Bruges Canal, 69
brush, 10, *11*, 58, *58*, 59, *59*
buildings, 86–91, *86–91*
bulldog clips, 9, *9*

cactus, 77, *77*
candle, 53, *53*
cartridge paper, 12, *13*
cats, *120*
centre of interest, 68, *68*
chalk, 8
charcoal, 8, 9, 42–5, *42–5*, 70, *70*
 compressed, 8
 pencils, 8
children, 96, *96*, 97, *97*
clothes, 108, *109*
colour, 74–83, *74–83*
 wheel, 75, *75*
coloured pencils, 10, 76, *76*

complementary colours, 74
composition, 64–7, *64–7*
construction lines, 26, *26*, 27
conté crayons and pencils, 8
craft knife, 8, *9*
crayons, 10
cross hatching, 38, *38*

dip pen, 8, *9*
Doorway in Dorset, A, 71
Dorset Landscape, 73
drapery, 108–9, *108–9*
drawing, 7, 36–7, *36–7*, 43, *43*
drawing board, 8, *8*
dry brush, 55, *55*
dry media, 16

easel, 10
ellipses, 27, *27*
enlarging, 65, *65*
expressionistic drawing, 37, *37*
eye level, 85–9, *85–9*

facial features *see* portraits
Farm Cottages, 70, 70
feet, 107, *107*
fibre tip pen, 8
Fish, 41, 41
fixative, 10, *10*
flowers, 35, *35*, 57, *57*, 60, *60*
foreshortening, 94, *94*

gable, 87
geranium, 76, *76*
globe artichoke, *126*
glossary, 127
gouache, 10
Grandmother and Granddaughter, 111, 111
graphite sticks, 8, *8*
groups, 98, *98*

hands, 106, *106*
hatching, 38, *38*
hats, 109, *109*
High Street, 90, 90–1
holidays, 116
horses, *122*
Hydrangeas and Cider Jar, 83, 83

Ingres paper, 73, *73*, 81, *81*, 104, *104*
ink, 8
 coloured, 19, *19*
 Indian, 56–8, *56–8*
 sepia, 58, *58*
 waterproof, 8, *9*

landscape, 68–83, *68–83*, 114–17, *114–17*
leaves and flowers, 34–5, *34–5*
life drawing, 94–5, *94–5*
light, 46–7, *46–7*
Lincoln Cathedral, 88, 88
line and wash, 60–3, *60–3*
local colour, 75

marks, 14–20, *14–20*
 charcoal, *16*
 conté, *16*
 on different papers, 17
 pencil, *14–15*
 pens, 16
 with colour media, *18, 19*
 with mixed media, *20, 21*
masking fluid, 53
masking tape, 9, *9*, 53, *53*
materials, 8–13, *9–11*
measuring, 24, *24*, 84
mirror, 52, *52*
mixed media, 20–1, *20–1*, 71, *71*
mood, 52
Mother and Child, 110, 110
mounting, 126

movement, 88, *89*, 98, *99*

negative spaces, 30–1, *30–1*
neutral colours, 75

observation, 23
oil pastels, 10, *10*, 18, *18*

palette, 10, *11*, 77
paper, 12–13
 cartridge, 12, 13
 pastel, 12, 13
 size, 12
 sketchbook, 13, *13*, 112, *112–13*
 stretching, 59
 sugar, 12, 13
 surface, 12
 types, 12
 watercolour, 12, 13
 weight, 12
pastel pencils, 73, *73*
pastels, 10, 18, *18*, 80–1, *80–1*
pattern, 50–1, *50–1*
pencils, 8, 9, 14–15, *14–15*
pens, 8, 9, 56–7, *56–7*
people, 92–3, *92–3*
perspective, 84–7, *84–7*
photographs, 114
plastic eraser, 9, *9*
portraits, 100–1, *100–1*, 104
 facial features, 105, *105*
 self-portrait, 102–3, *102–3*
practice, 25
pressure, 23, *23*
primary colours, 74, 78, *78*
proportion, 92, *92*
 in portraits, 100

recording, 36, *36*
reed pen, 8
reflected light, 47, *47*

reflections, 124–25, *125*
ruler, 9

scale and distance, 84
seed heads, 42, *42*
self portrait *see* portraits
setting up, 102
shading, 38, *38*
shadow, 46, *46*
sheep, *122*
shells, 58–9, *58–9*
shoes, 32–3, *32–3*, 107
sight size, 26
simplifying, 93, *93*
sketchbook, 13, *13*, 112, *112–13*
sketchbooks, 7, 13, *13*, 112–13, *112–13*
spatter, 54, *54*
stencils, 55, *55*
stipple, 38–40, *38–40*
storage, 126
storage box, 9, 12
structure, 34, *34*, 92, *92*
sugar paper, 12, *12*
sunlight, 88

techniques, 53
 blotting paper, 55
 candle, 53
 card, 54
 glue brush, 53
 masking fluid, 53
 masking tape, 53
 sponge, 54
 stipple brush, 55
 straws, 55
 toothbrush, 54
 wax crayon, 53
textural qualities, 49
texture, using:
 brushstrokes, 49
 charcoal, 48
 conté pencil, *48–9*

4B pencil, 48
pen & ink, *48–9*
thumbnail drawings, 28, 64–6, *65–6*, 72, *72*
tonal scale, 39, *39*, 66, 67
tone, 38–41, *38–41*
torchon, tortillon, 9, *9*, 38
Town Gardens, 82
transferring an image, 65, *65*
trees, 118–19, *118–19*
two figures, 110–11, *110–11*

vanishing points, 86, *86*
Vegetables, 28–9, 28–9
verticals, 24, *24*, 85, *85*, 115

wash, 60, 62, *62*, 69, *69*, 79, *79*
water, 124
watercolour, 10, 78–9, *78–9*
watercolour brush, 10, *11*
watersoluble coloured crayons, 10, *11*, 21, *21*
watersoluble pencils, 8–10, *9*, 77, *77*
wax crayons, 10, *11*
Welsh Landscape, 69
wet-into-wet, 78, *79*
wet media, 16